Enchanted Fairy Tales

ART STUDIO PROJECT BOOK

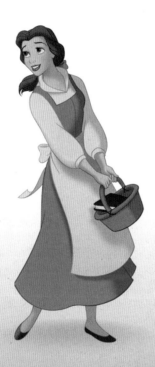

Illustrated by The Disney Storybook Artists

THUNDER BAY
P·R·E·S·S
San Diego, California

Thunder Bay Press
An imprint of Printers Row Publishing Group
A division of Readerlink Distribution Services, LLC
10350 Barnes Canyon Road, Suite 100, San Diego, CA 92121
www.thunderbaybooks.com

Packaged by

Walter Foster Publishing
An imprint of The Quarto Group
6 Orchard Road, Suite 100, Lake Forest, CA 92630
quartoknows.com

Publisher: Peter Norton

ISBN: 978-1-68412-214-1

Made in Shenzhen, China.

21 20 19 18 17 1 2 3 4 5

MIX
Paper from
responsible sources
FSC® C017606

Table of Contents

Tools & Materials

DRAWING PENCIL AND PAD (NOT SHOWN)

The drawing pencil in this kit has an HB lead hardness. This pencil won't smear easily like soft pencils do or scratch the surface of watercolor paper like hard pencils. Practice using the drawing pencil on the paper pad included with this kit.

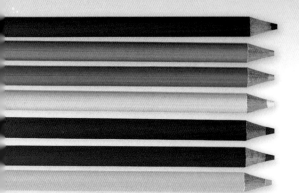

COLORED PENCILS

This kit contains seven colored pencils. Be sure to store them in the kit or a separate container. The lead in a colored pencil is brittle and likely to break inside the shaft if the pencil is dropped. This may not be immediately apparent, but will eventually render the pencil useless.

FINE-LINE BLACK MARKER

Use the fine-tipped black marker to ink your drawings. You can also experiment with ink, brush, dip, and ballpoint pens for different effects. Whenever possible, work with black waterproof ink for more permanent results.

SHARPENER

You can achieve various effects depending on how sharp or dull your pencil is, but generally you'll want to keep your pencils sharp. A sharp point will provide a smooth layer of color.

KNEADED ERASER

The success of erasing colored pencil marks depends on two main factors: the color of the pencil line and the amount of pressure that was applied. Darker colors tend to stain the paper, making them difficult to remove, and heavy lines are difficult to erase, especially if the paper's surface has been dented.

WATERCOLOR PAINTS

This kit contains three watercolor paints in tubes. Watercolor paints are commonly available in three forms—tubes, pans, and cakes. Most artists prefer tubes because the paint is already moist and mixes easily with water.

PAINTBRUSHES

Many paintbrush styles are available, but two are most commonly used with watercolor—flat brush and round brush. A flat brush has bristles of equal length that produce even strokes. A round brush has bristles that taper to a point, which allows it to hold a good amount of water. You can also vary your pressure on the brush to create a variety of stroke widths.

PALETTE

The plastic palette in this kit features several wells for pooling and mixing your watercolors. It's easily cleaned with soap and water.

Colored Pencil Basics

HOLDING THE PENCIL

The way you grip the pencil directly impacts the strokes you create. Some grips will allow you to press more firmly on the pencil, resulting in dark, dense strokes. Others hinder the amount of pressure you can apply, rendering lighter strokes. Still others give you greater control over the pencil for creating fine details. Experiment with each of the grips below.

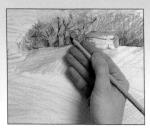
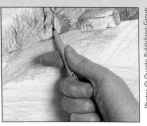

Photos © Quarto Publishing Group

Underhand Grip By cradling the pencil, you control it by applying pressure only with the thumb and index finger. This grip can produce a lighter line. Your whole hand should move (not just your wrist and fingers).

Conventional Grip For the most control, grasp the pencil about 1½" from the tip. Hold it the same way you write, with the pencil resting firmly against your middle finger. This grip is perfect for smooth applications of color, as well as for making hatch strokes and small, circular strokes.

Overhand Grip Guide the pencil by laying your index finger along the shaft. This is the best grip for strong applications of color made with heavy pressure.

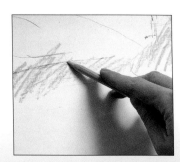

PRESSURE

Your main tool for darkening the color with colored pencils is the amount of pressure you use. It is always best to start light so that you maintain the tooth (or the texture of roughness or smoothness) of the paper for as long as possible.

Light Pressure Here, color was applied by whispering a sharp pencil over the paper's surface. With light pressure, the color is almost transparent.

Medium Pressure This middle range creates a good foundation for layering.

Heavy Pressure Pushing down on the pencil flattens the paper's texture, making the color appear almost solid.

Watercolor Basics

Watercolor paint straight from the tube is generally too dry and thick to work with, so you'll need to dilute it with water. The less water you use, the more intense the color will be.

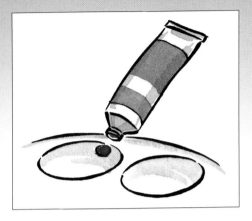

Starting Out Small Watercolors are very concentrated—a little goes a long way. Start by squeezing out a pea-sized amount of paint into one of the wells of your mixing palette.

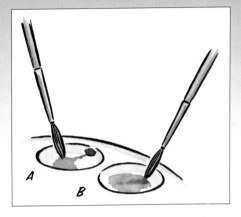

Diluting the Paint Dip your brush in clean water, and then mix the water with the paint. Keep adding water until you achieve the dilution level you want (A). You can also transfer some of the paint to a separate well for mixing with other colors or for diluting the paint further (B).

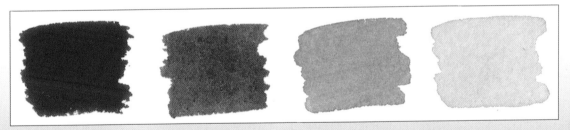

Dilution Chart Here's how brilliant red looks in four different dilution levels, from slightly diluted to very diluted.

TESTING YOUR COLORS

It's always a good idea to have a piece of scrap paper handy to test your colors before applying them to your painting.

Color Basics

Color can help bring your drawings to life, but first it helps to know a bit about color theory. There are three *primary* colors: red, yellow, and blue. These colors cannot be created by mixing other colors. Mixing two primary colors produces a *secondary* color: orange, green, and purple (or violet). Mixing a primary color with a secondary color produces a *tertiary* color: red-orange, yellow-orange, yellow-green, blue-green, blue-purple, and red-purple. Reds, yellows, and oranges are "warm" colors; greens, blues, and purples are "cool" colors.

THE COLOR WHEEL

A color wheel is useful for understanding relationships between colors. Knowing where each color is located on the color wheel makes it easy to understand how colors relate to and react with one another.

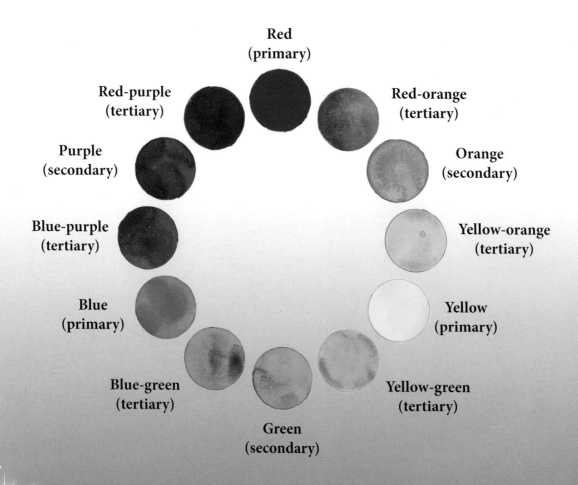

Red (primary)

Red-orange (tertiary)

Red-purple (tertiary)

Orange (secondary)

Purple (secondary)

Yellow-orange (tertiary)

Blue-purple (tertiary)

Yellow (primary)

Blue (primary)

Yellow-green (tertiary)

Blue-green (tertiary)

Green (secondary)

EASY COLOR COMBINATIONS

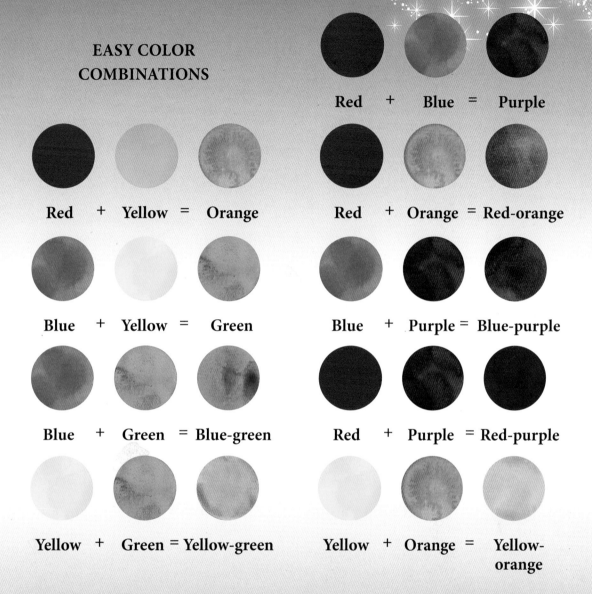

Red + **Blue** = **Purple**

Red + **Yellow** = **Orange**

Red + **Orange** = **Red-orange**

Blue + **Yellow** = **Green**

Blue + **Purple** = **Blue-purple**

Blue + **Green** = **Blue-green**

Red + **Purple** = **Red-purple**

Yellow + **Green** = **Yellow-green**

Yellow + **Orange** = **Yellow-orange**

BLENDING COLORED PENCILS

Colored pencils are transparent by nature, so instead of "mixing" colors as you would for painting, you create blends directly on the paper by layering colors on top of one another.

ADDING COLOR TO YOUR DRAWING

Some artists draw on illustration board or watercolor paper and then apply color directly to the original pencil drawing; however, if you are a beginning artist, you might opt to preserve your original pencil drawing by making several photocopies and applying color to a photocopy. This way, you'll always have your original drawing in case you make a mistake or you want to experiment with different colors or mediums.

How to Use This Book

You can draw any of the characters in this book by following these simple steps.

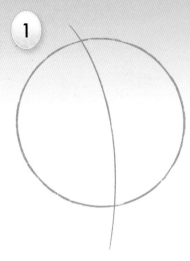

1

First draw the basic shapes, using light lines that will be easy to erase.

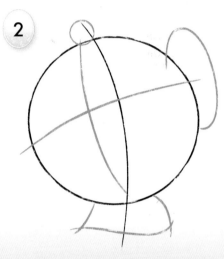

2

Each new step is shown in blue, so you'll always know what to draw next.

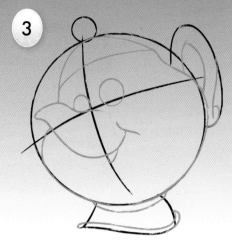

3

Take your time and
copy the blue lines,
adding detail.

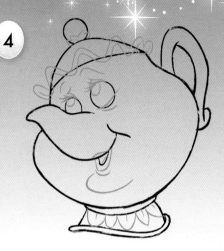

4

Darken the lines you want to
keep, and erase the rest.

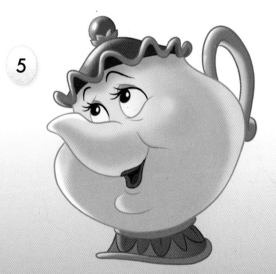

5

Add color to your drawing with
colored pencils, markers, paints,
or crayons!

Cinderella

Though Cinderella lives a life of servitude, she greets each day full of hope
that her destiny will change. She imagines how wonderful it would be to
fall in love with a handsome prince who would treat her with kindness.
Thanks to her Fairy Godmother, that day may come sooner than she thinks.
Meanwhile, Cinderella never stops believing in her dreams.

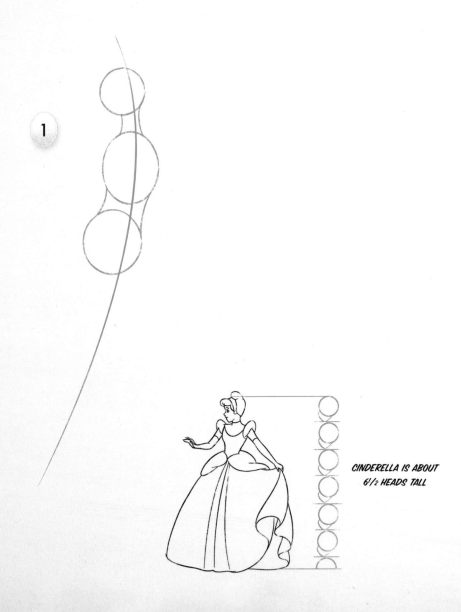

1

CINDERELLA IS ABOUT
6½ HEADS TALL

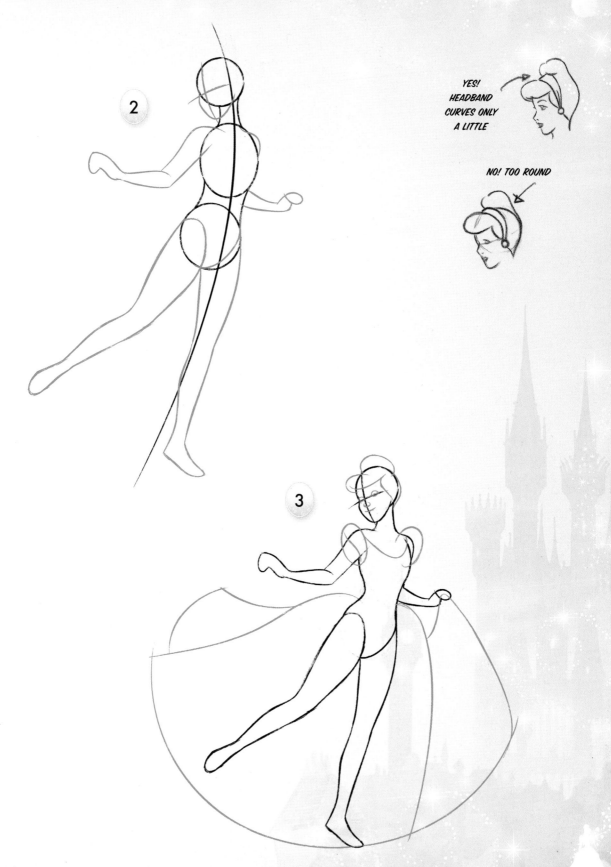

2

YES!
HEADBAND
CURVES ONLY
A LITTLE

NO! TOO ROUND

3

 CINDERELLA HAS ALMOND-SHAPED EYES

YES! EYELIDS HAVE SLIGHT S-CURVE

NO! NOT DROOPY— AVOID SAD EYES

4

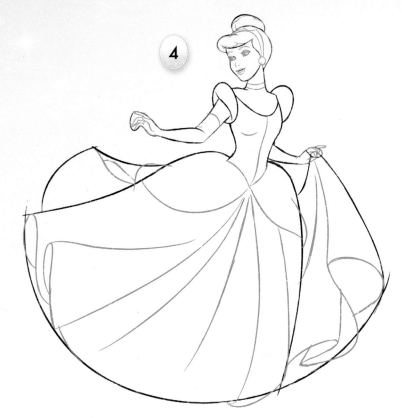

5

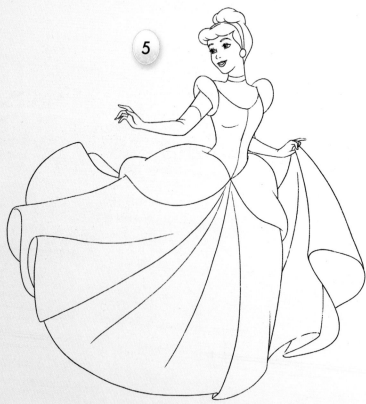

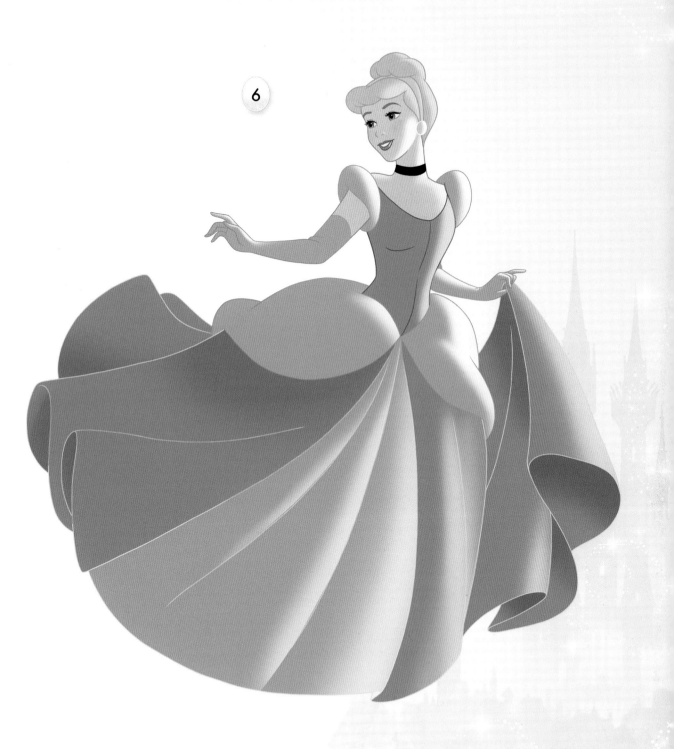

6

Gus & Jaq

Quick-thinking Jaq and clumsy Gus are good friends and make a great team, especially when it comes to protecting Cinderella and helping her achieve a happily ever after.

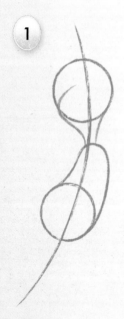

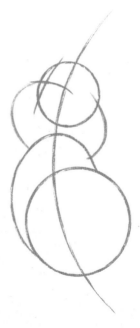

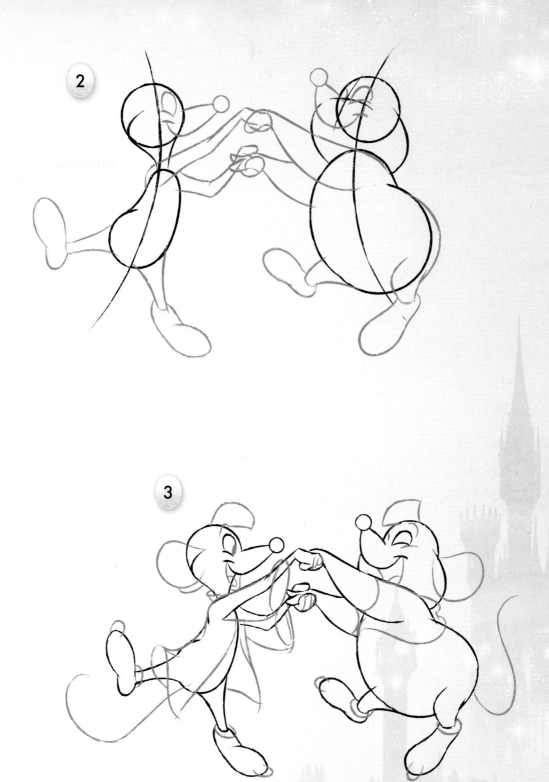

2

3

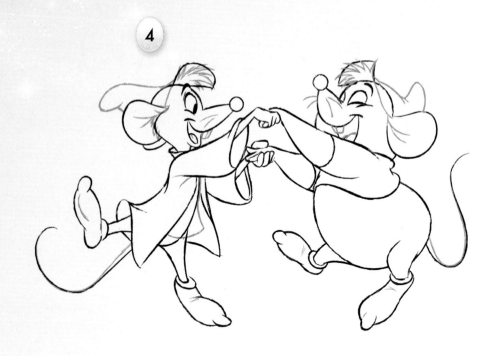

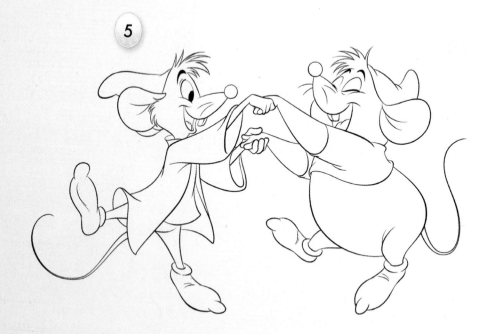

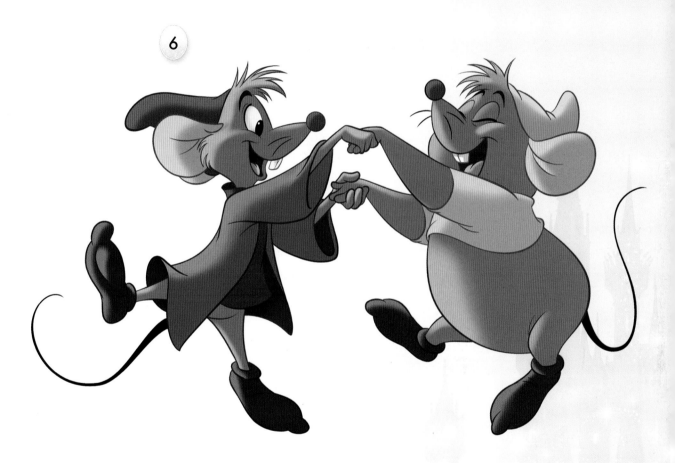

6

Lucifer

Lucifer, the devilish pet cat of Lady Tremaine, has black fur, sharp claws, and a toothy grin. He is a sneaky feline who loves nothing more than tormenting Cinderella and catching mice.

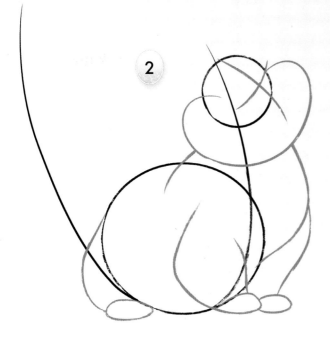

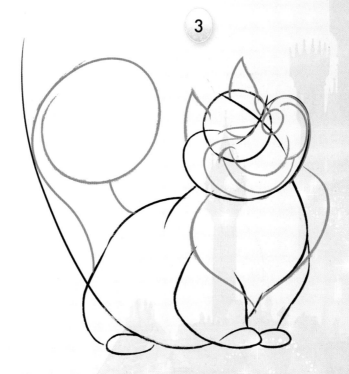

4

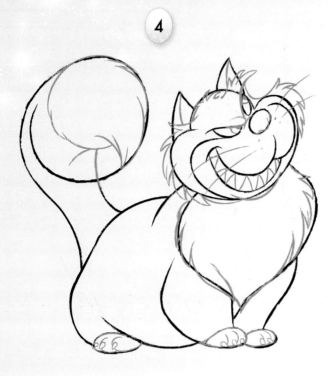

5

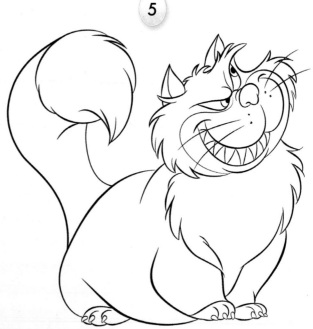

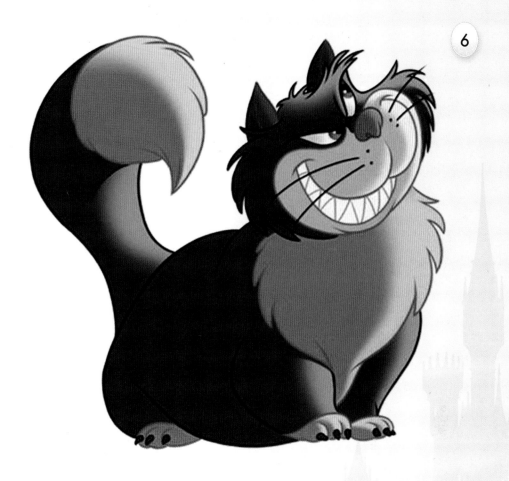

Belle

Belle is a simple country girl with a natural beauty that is due as much to her inner goodness as it is to her appearance. When drawing her, notice how soft curves create her simple beauty.

1

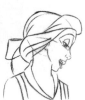

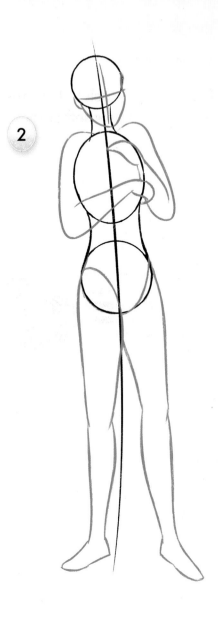

2

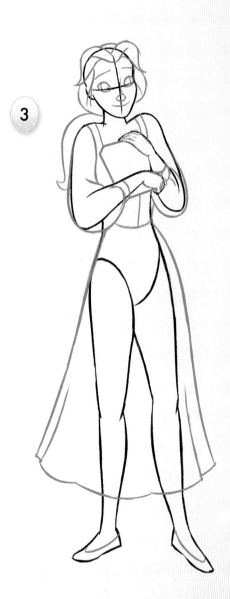

3

BELLE'S FACIAL FEATURES
FOLLOW THESE GUIDELINES

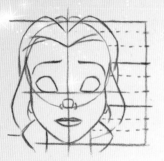

HAIR BOW EXTENDS
BEYOND CHIN LINE

5

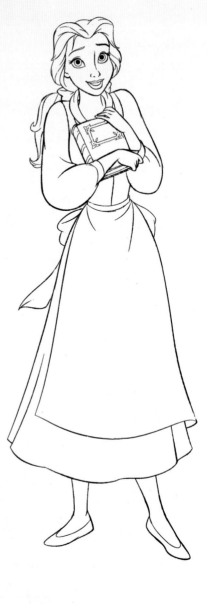

4

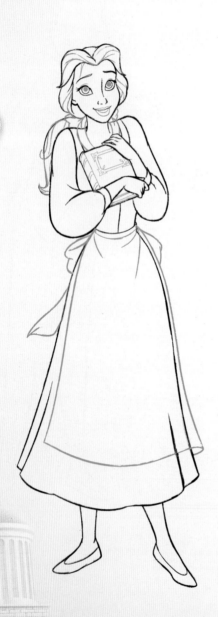

26

YES! BELLE'S
EYES HAVE
SLIGHT
ANGLES

ANGLE

ANGLE

NO! NOT
SMOOTH OVAL

6

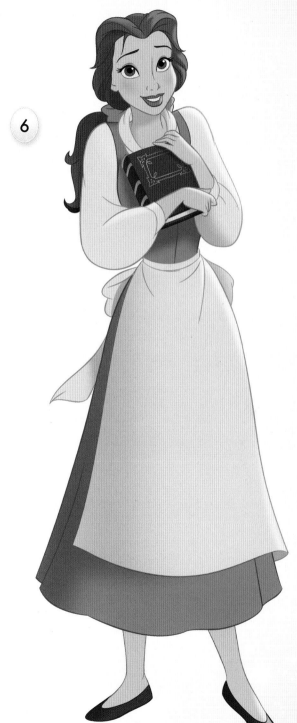

YES! UPPER LIP IS THINNER
THAN LOWER LIP

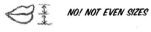

NO! NOT EVEN SIZES

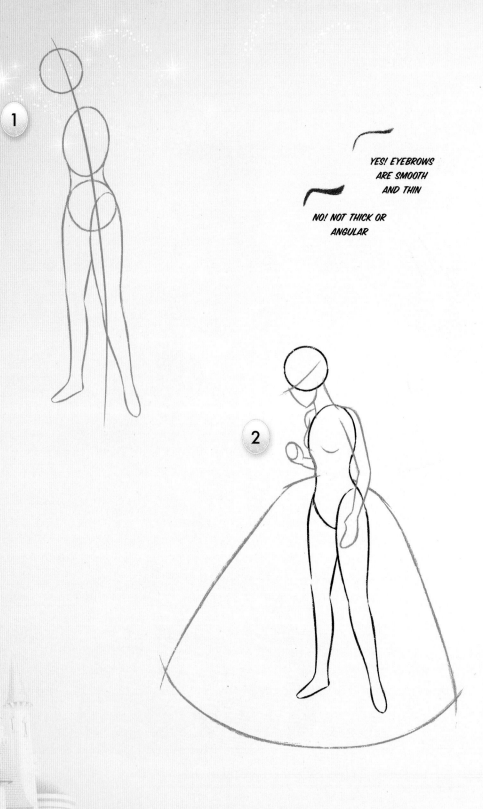

YES! EYEBROWS
ARE SMOOTH
AND THIN

NO! NOT THICK OR
ANGULAR

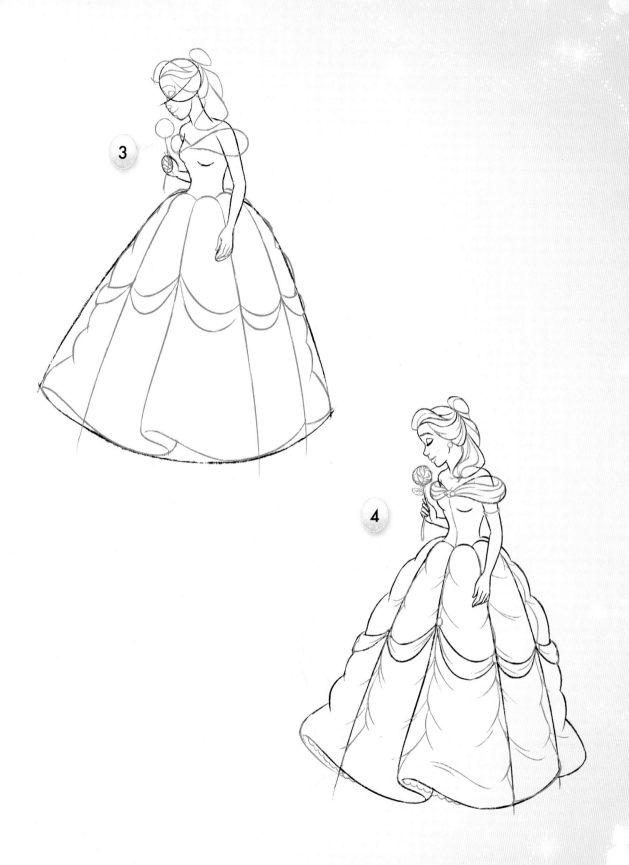

3

4

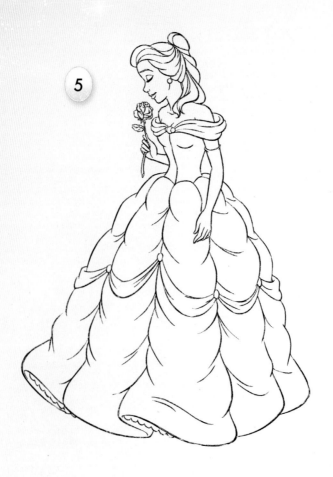

5

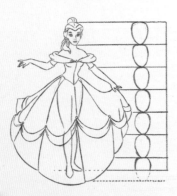

BELLE IS ABOUT 6½ HEADS TALL

YES! HAIR CURVES
AROUND HEAD

NO! NO STRAIGHT
LINE ACROSS HEAD

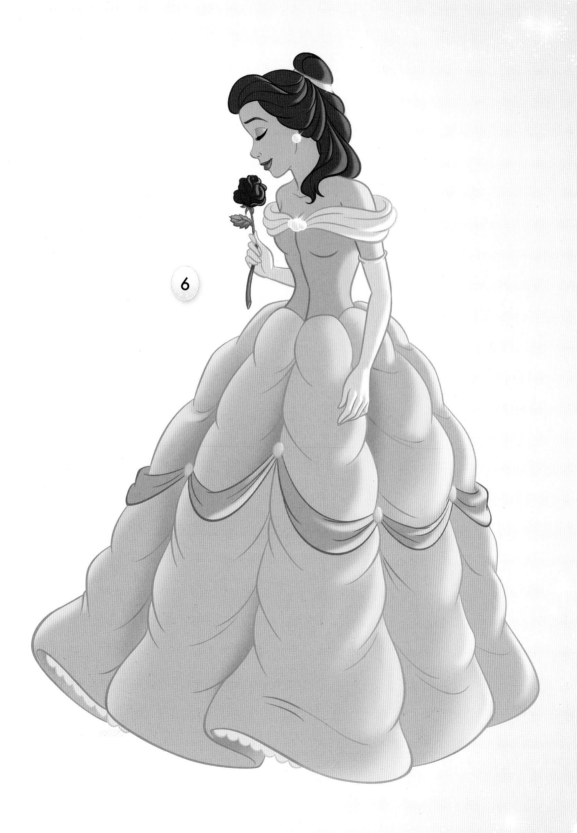

6

The Beast

His temper may often get the better of him, but the Beast has
a softer side that only Belle can bring out. Those claws along with
his horns and angry eyebrows scare most people away.

KEEP NECK SHAPE
DISTINCT FROM CHEST'S
OVAL SHAPE

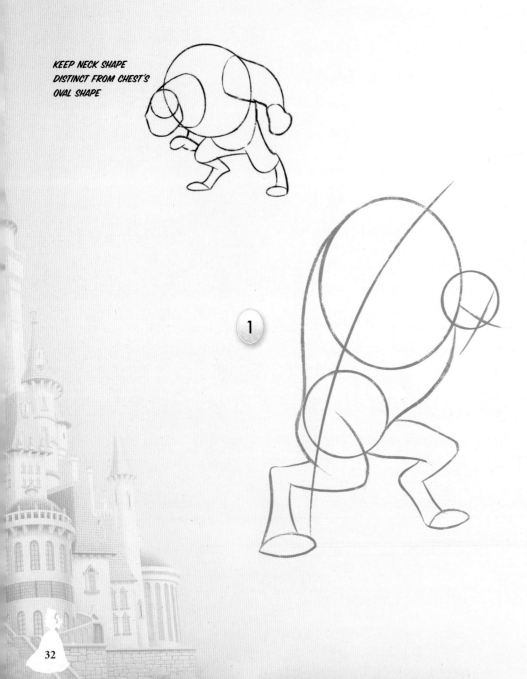

1

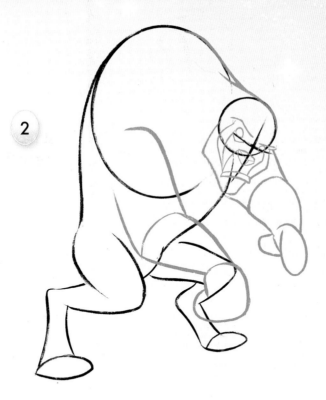

2

YES! HANDS ARE STRONG ANIMAL PAWS

NO! NOT ROUND, SOFT HANDS

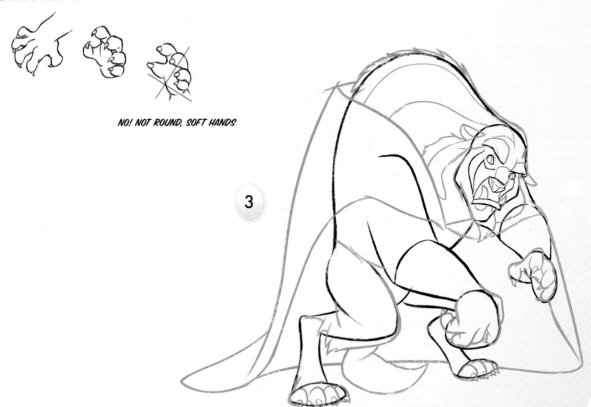

3

4

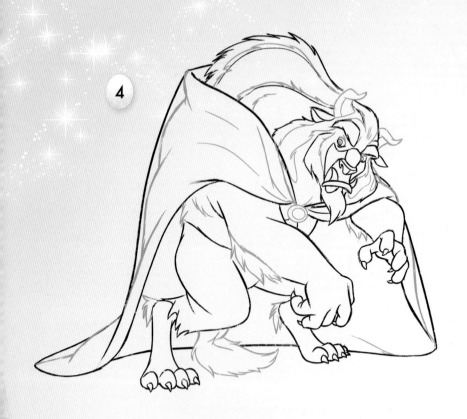

5

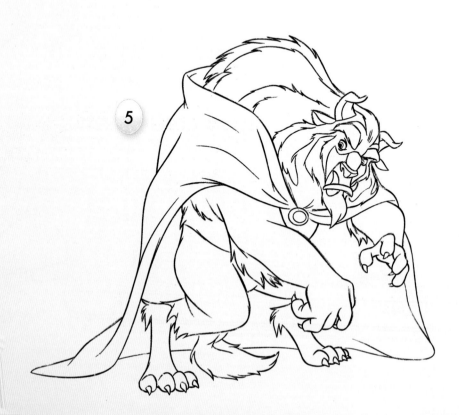

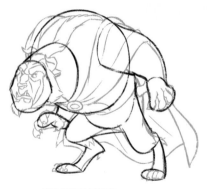

THE BEAST WALKS
ON HIS TOES

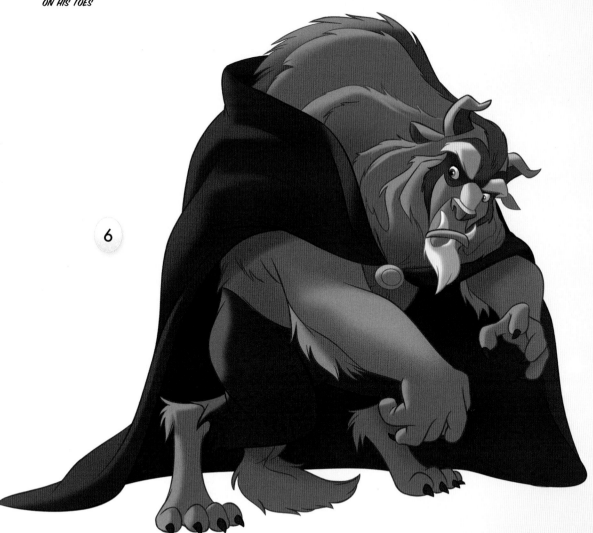

6

Lumière

Voilà! Best friends and also rivals of sorts, Lumière and Cogsworth keep the household running and on course—and they try to do the same for the Beast!

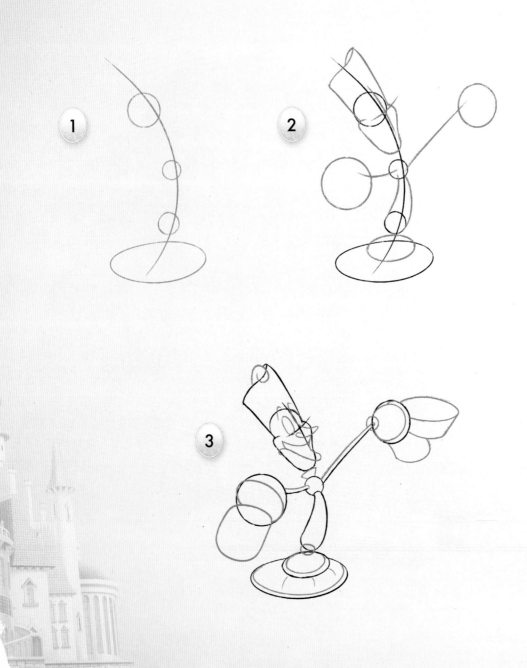

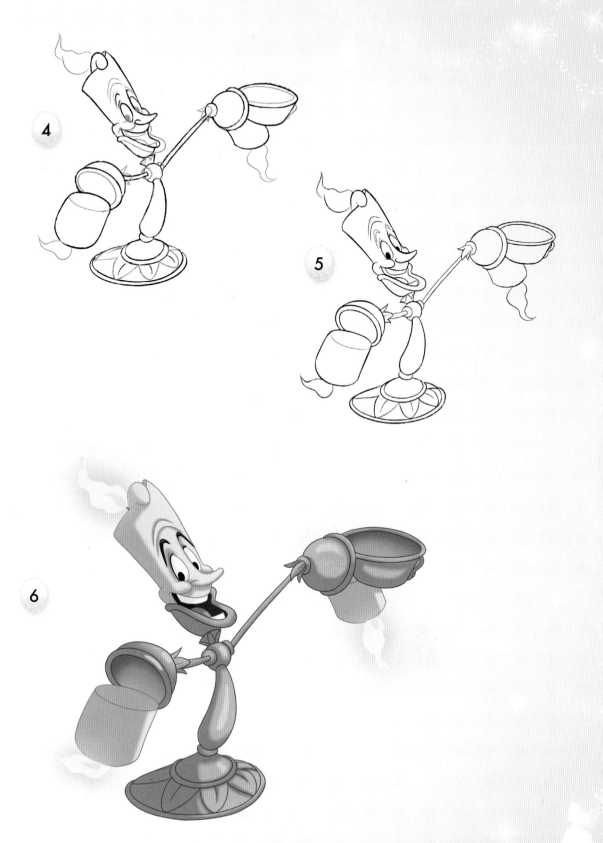

Cogsworth

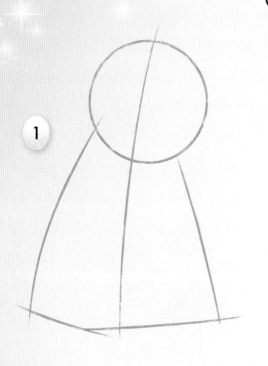

1

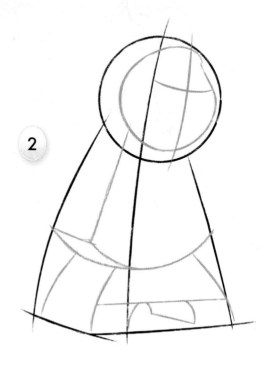

2

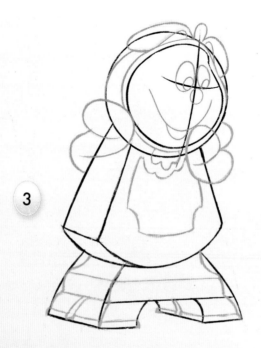

3

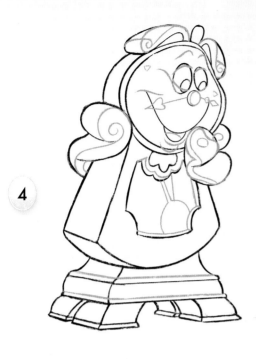

4

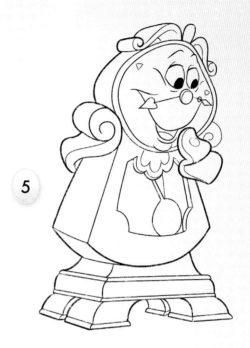

5

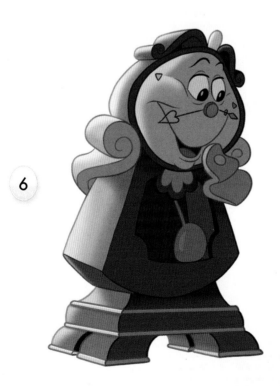

6

Mrs. Potts & Chip

With a spot of tea, Mrs. Potts can make any situation better. And her inquisitive son Chip keeps everyone's spirits up by shooting water through his front teeth.

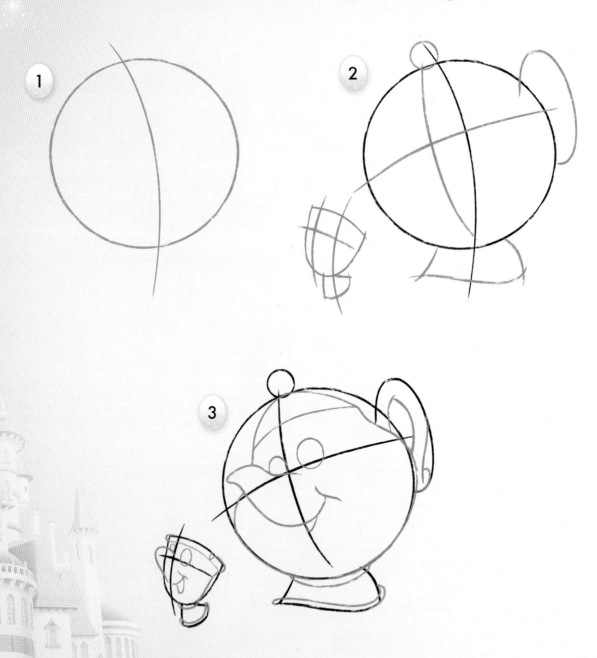

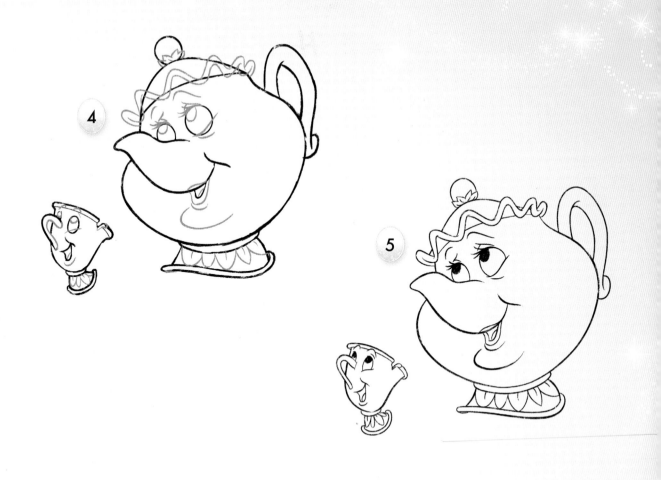

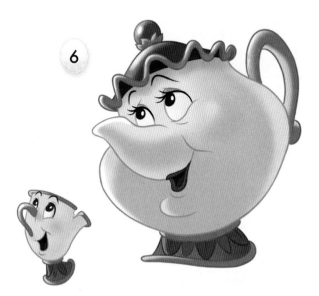

Gaston

Gaston, a handsome but arrogant hunter, is considered to be the town hero. He is only interested in physical appearances, and often makes fun of Belle for reading books.

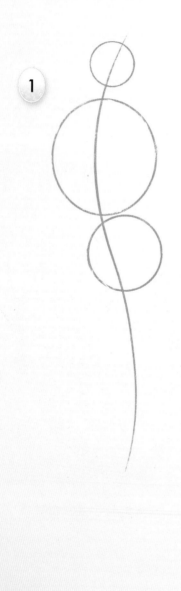

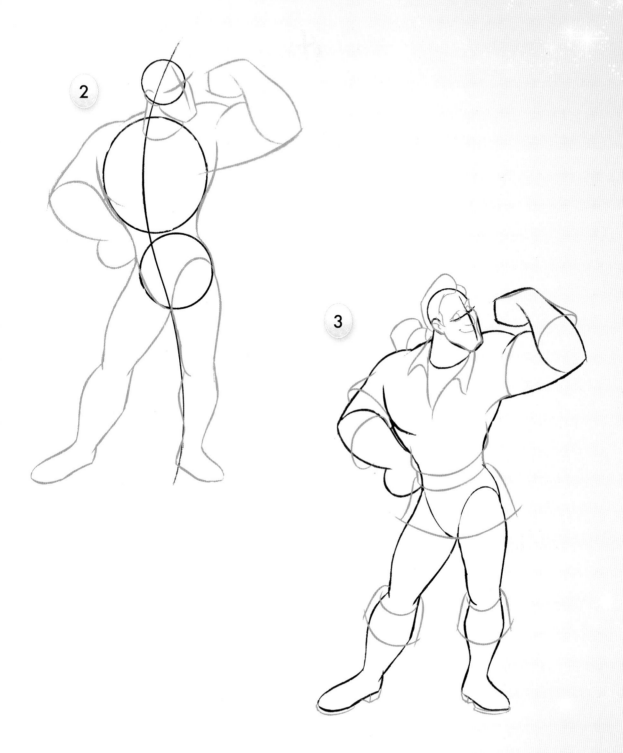

2

3

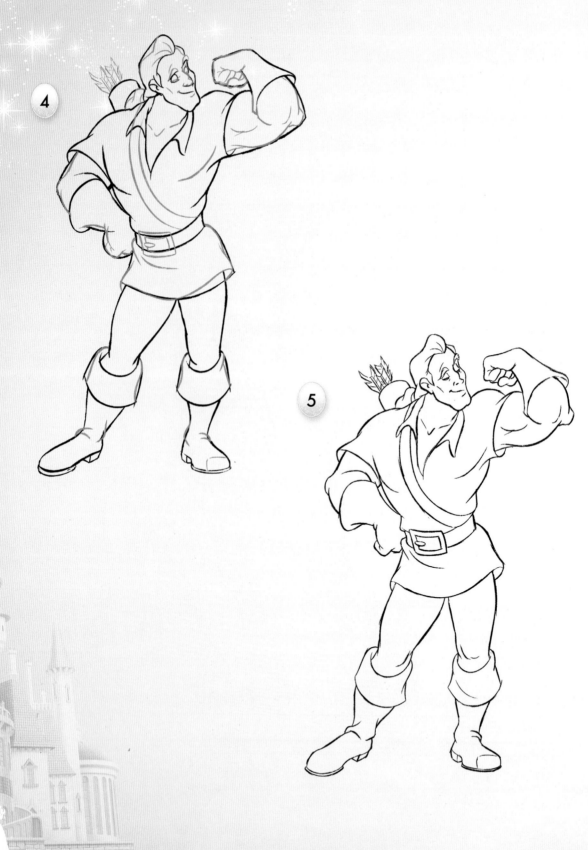

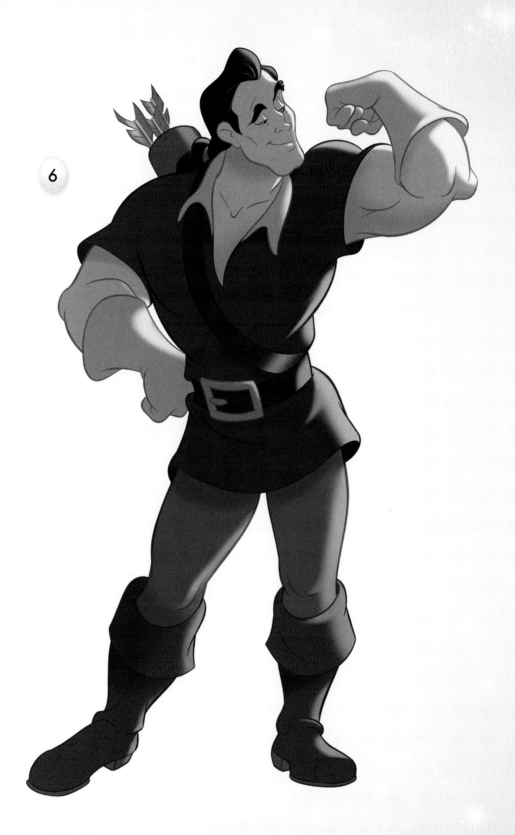

6

Ariel

Ariel's cheerful enthusiasm, engaging mannerisms, and unmatched charm all come to life in this pose. A strong line of action will help give the feeling that Ariel's body flows naturally into her graceful tail!

1

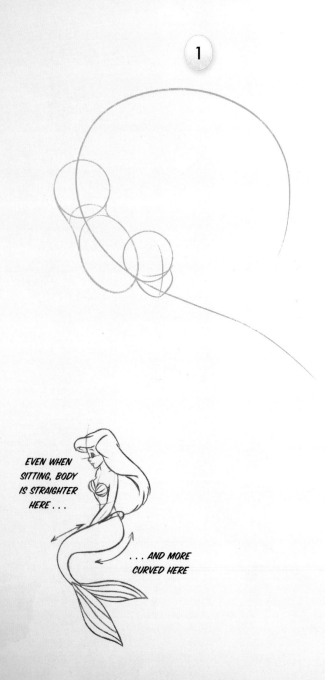

EVEN WHEN
SITTING, BODY
IS STRAIGHTER
HERE . . .

. . . AND MORE
CURVED HERE

2

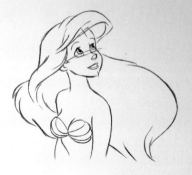

HAIR BILLOWS
OUT, ESPECIALLY
UNDERWATER

3

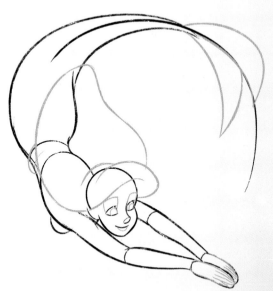

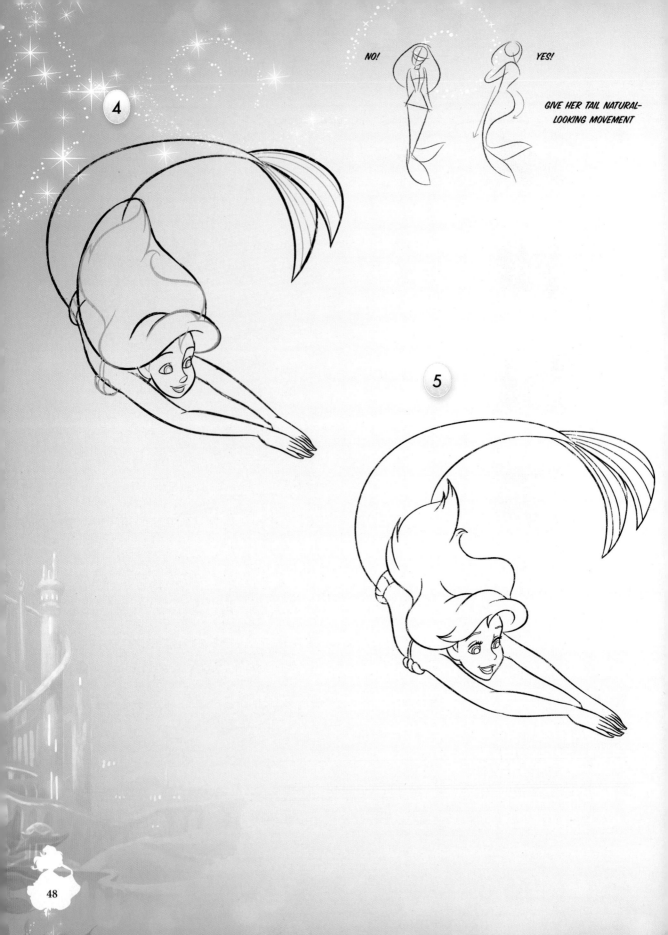

4

NO!

YES!

GIVE HER TAIL NATURAL-
LOOKING MOVEMENT

5

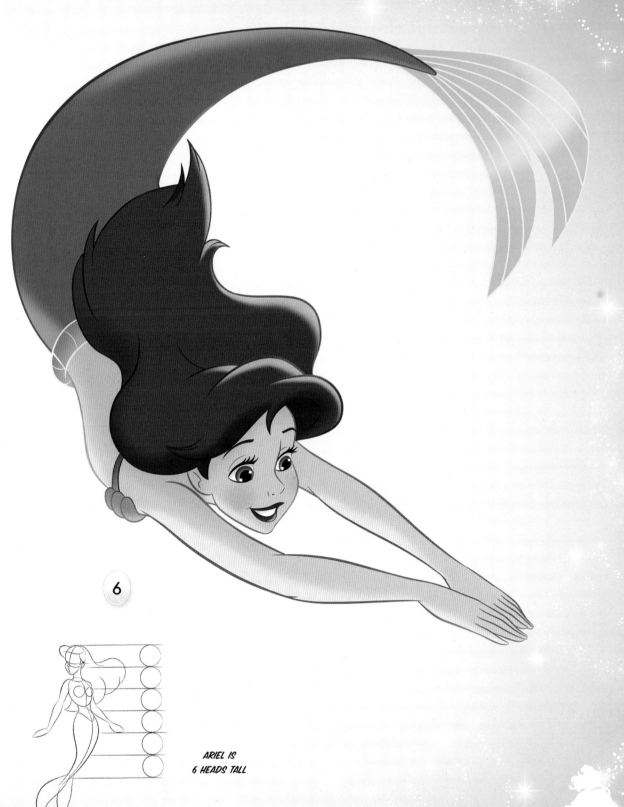

6

ARIEL IS
6 HEADS TALL

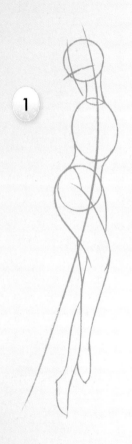

1

YES! OVAL NOSE IS
ANGLED LIKE THIS

NO! NOT HORIZONTAL
LIKE THIS

YES! ARIEL'S
BANGS POOF
OUT OVER HER
FOREHEAD

NO! HAIR
DOESN'T
COVER FACE

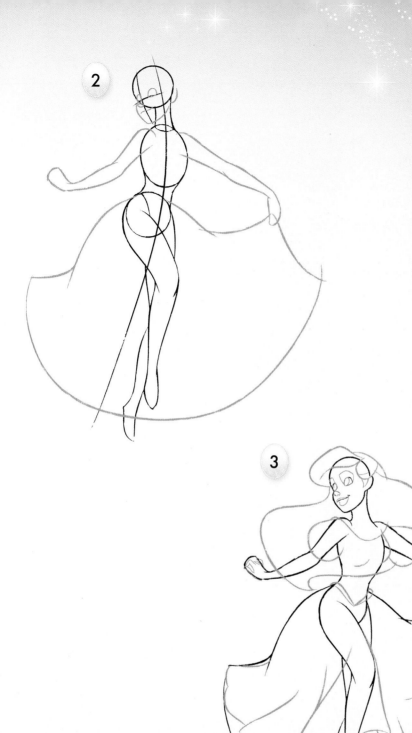

2

3

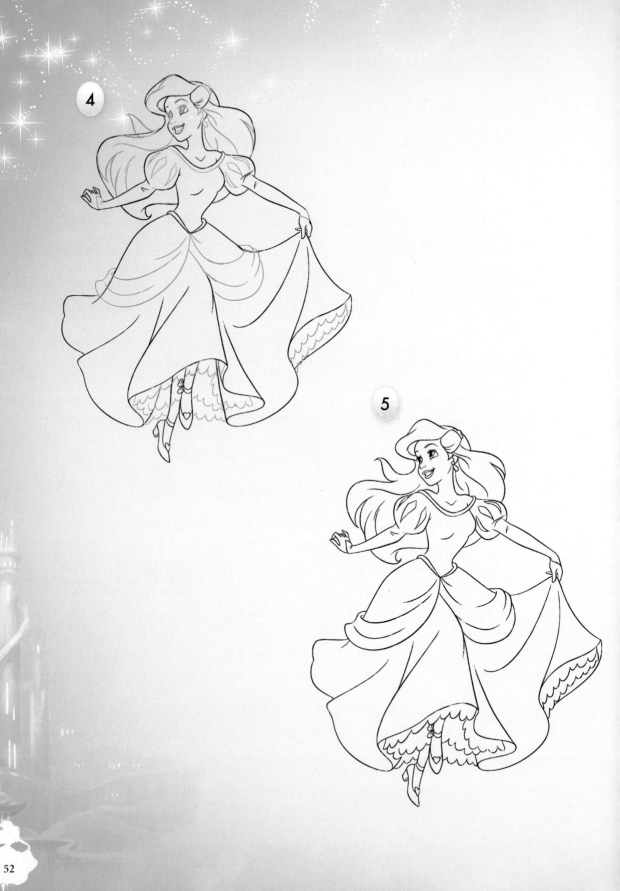

4

5

EACH EYEBROW IS ONE THIN LINE

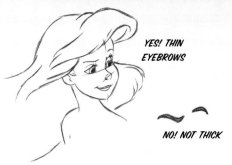

YES! THIN
EYEBROWS

NO! NOT THICK

6

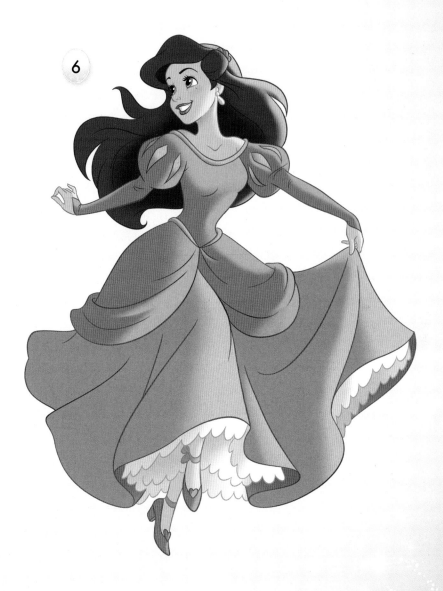

53

Prince Eric

Eric is a brave, athletic prince who loves the high seas, and his handsome looks capture Ariel's heart. Make sure to show his love for adventure when drawing him in an action pose.

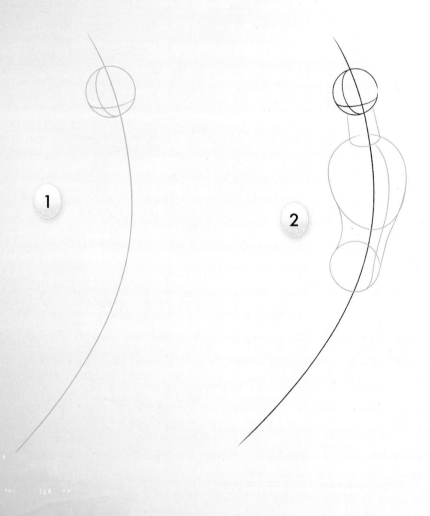

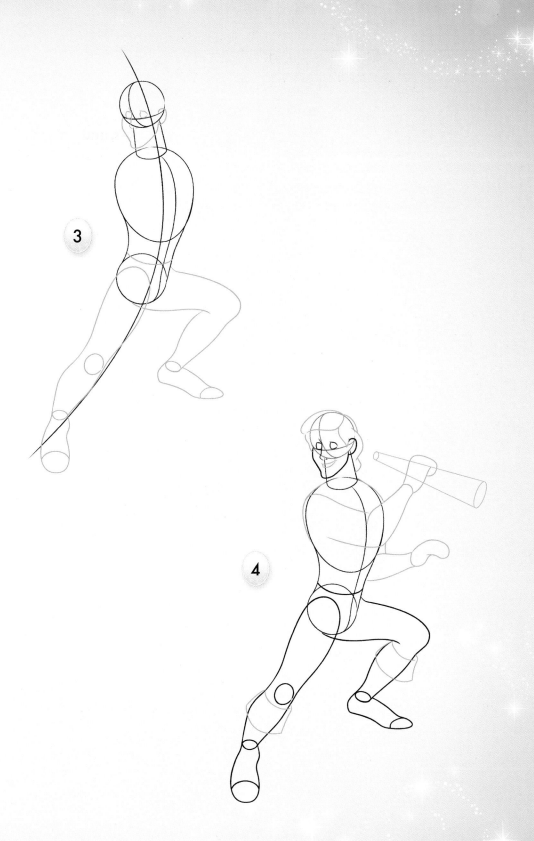

3

4

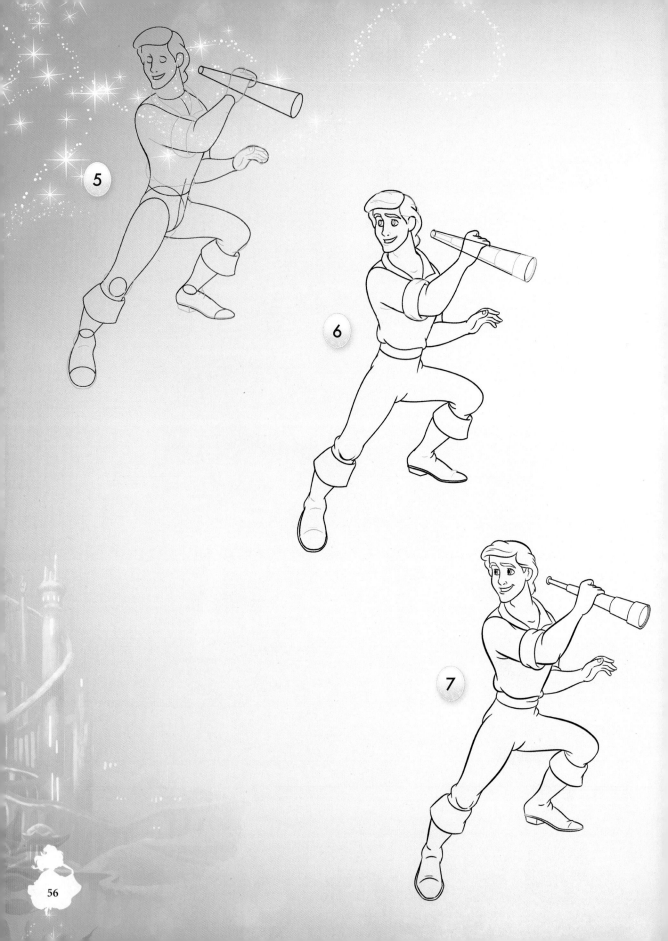

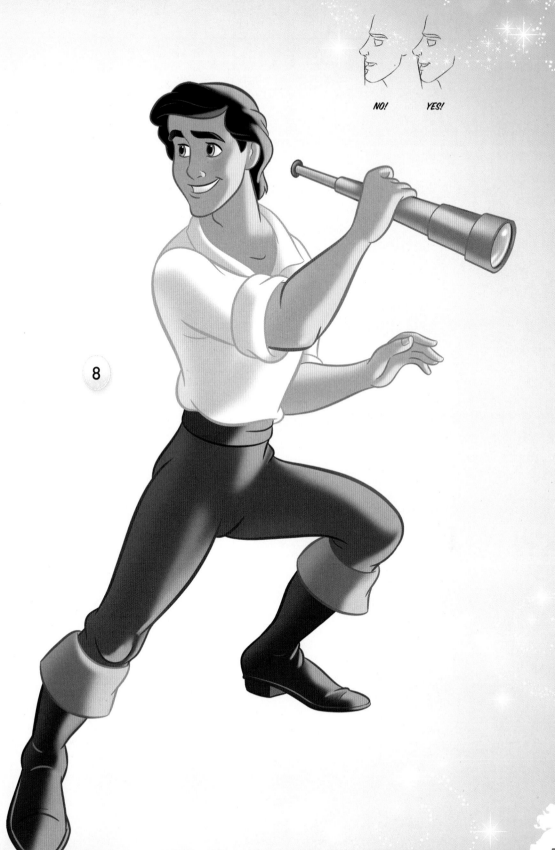

NO! YES!

8

Sebastian

Sebastian is a little crab with a big heart—and an even bigger voice. He is tasked by King Triton with keeping an eye on Ariel, but "tagging along with some headstrong teenager" isn't an easy job. Good thing Sebastian has a good sense of humor, along with a great set of pipes.

3

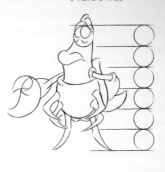

4

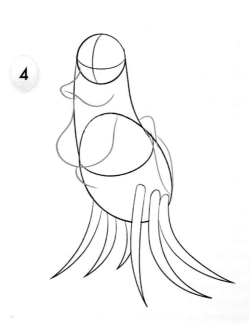

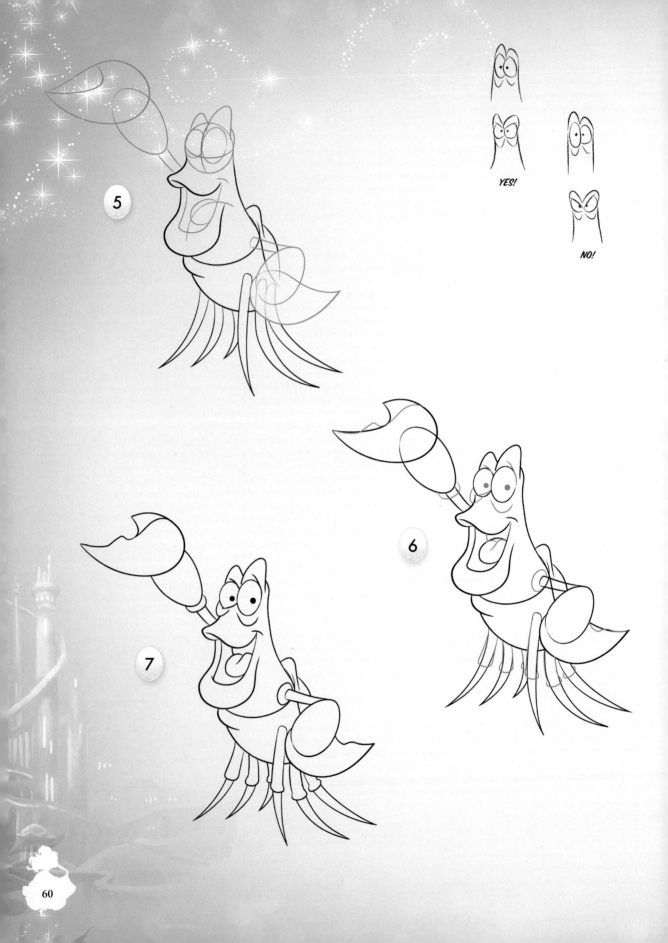

YES!

NO!

5

6

7

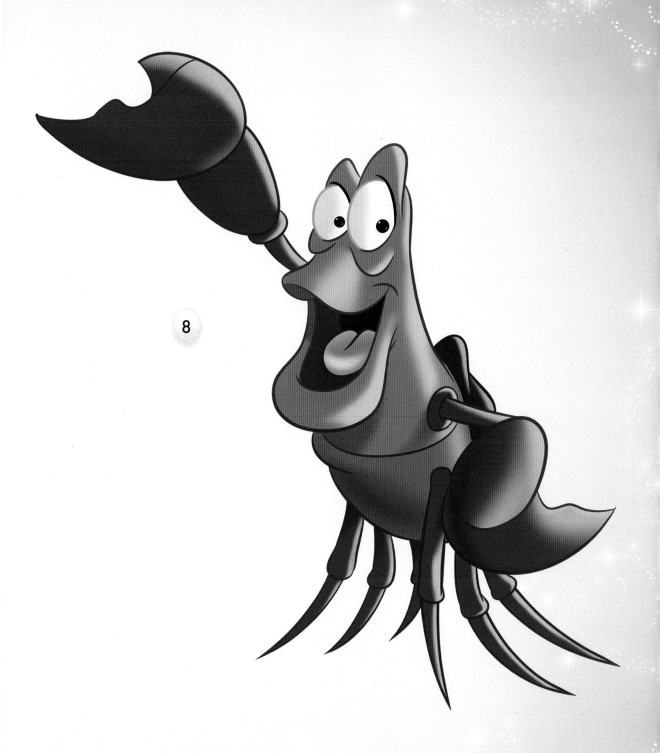

8

Flounder

Ariel's loyal best friend, Flounder, is full of spunk. He has an innocence and vulnerability, so he can scare easily, but when it comes to his little mermaid, Flounder never lets her down!

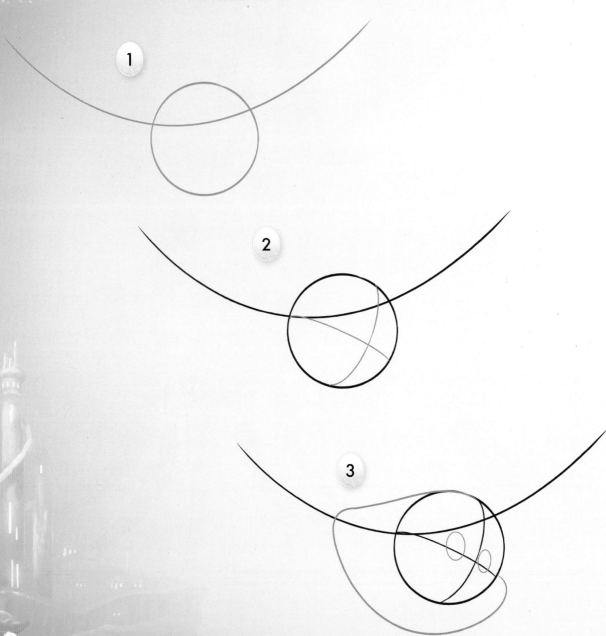

4

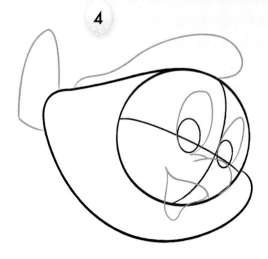

5

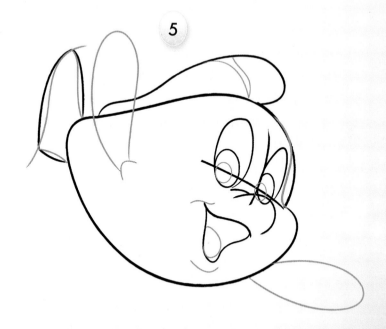

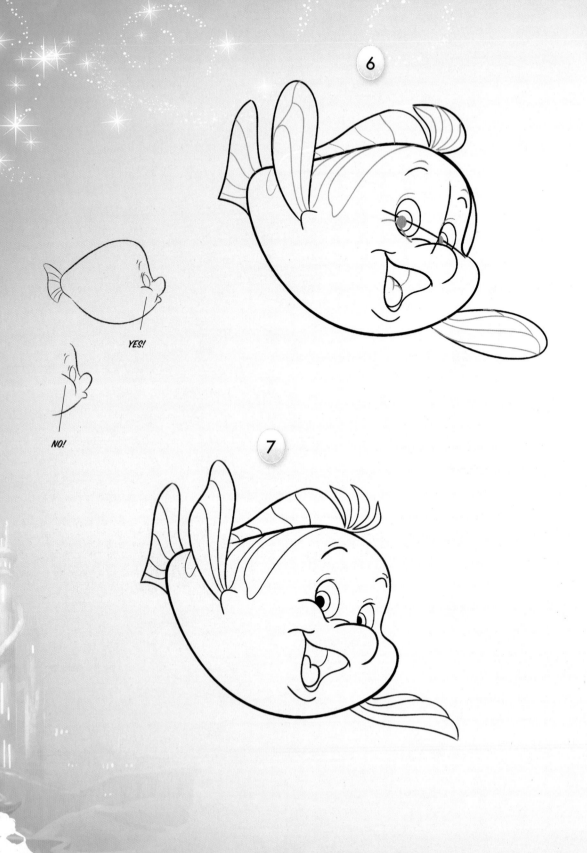

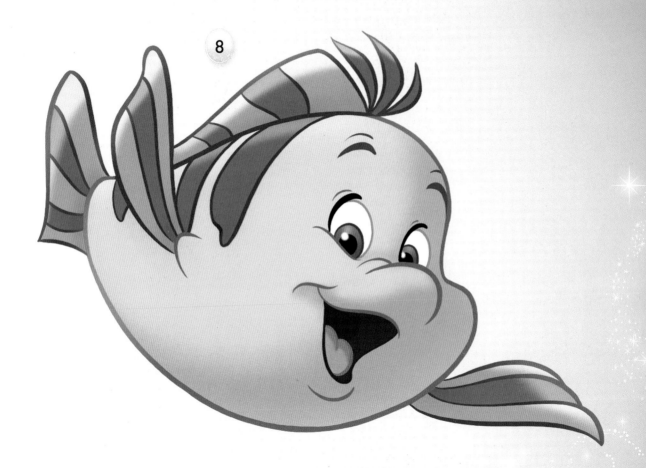

8

Snow White

Snow White is the fairest one in the land. She is full of innocence, charm, and sweetness. When you draw Snow White, be sure to show the soft, sweeping lines in her dress and the gentle arm movements that emphasize her cheerful, sweet disposition and her joy for life.

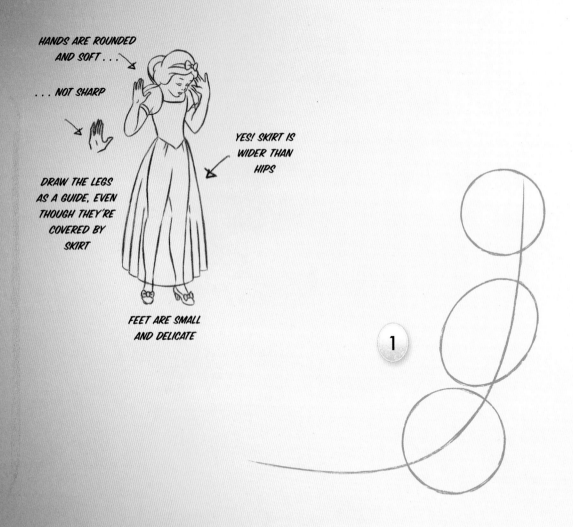

HANDS ARE ROUNDED AND SOFT . . .

. . . NOT SHARP

DRAW THE LEGS AS A GUIDE, EVEN THOUGH THEY'RE COVERED BY SKIRT

YES! SKIRT IS WIDER THAN HIPS

FEET ARE SMALL AND DELICATE

1

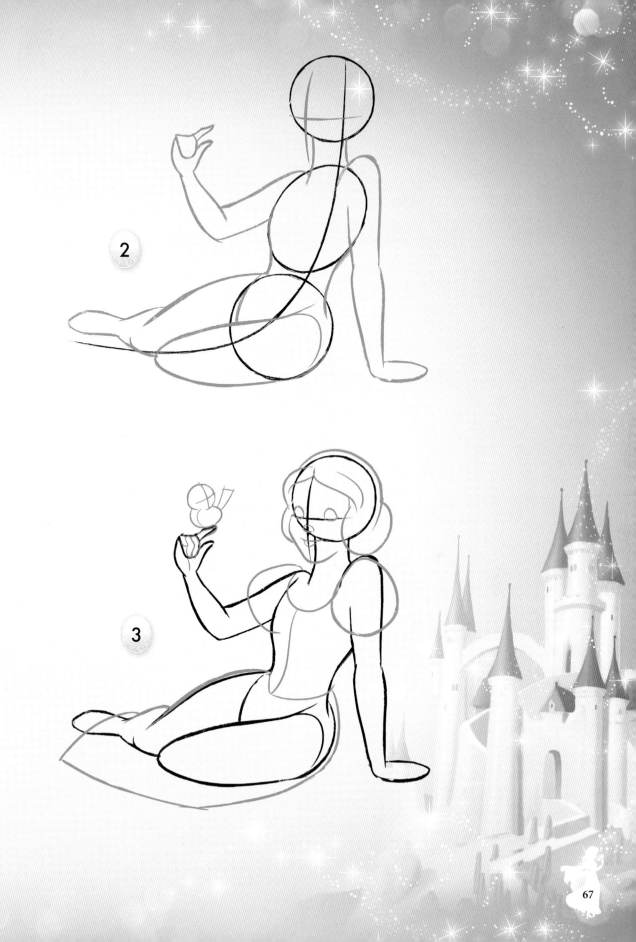

2

3

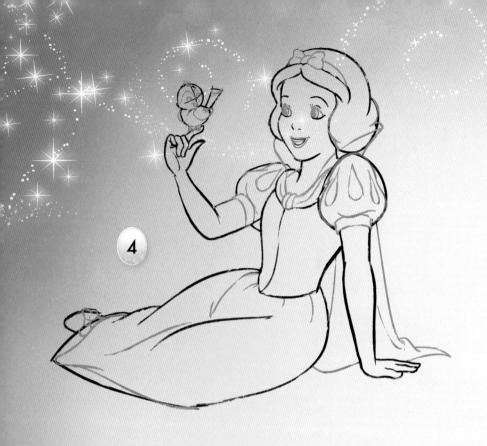

4

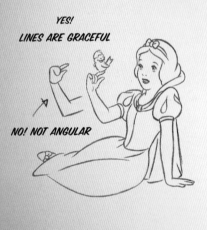

YES!
LINES ARE GRACEFUL

NO! NOT ANGULAR

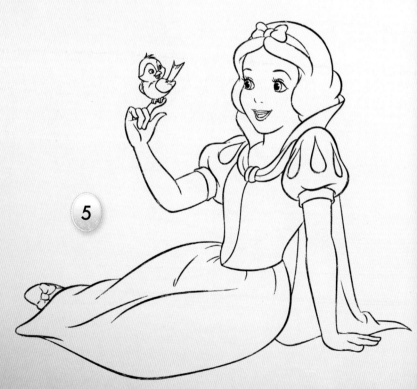

5

NO! BRIDGE OF
SNOW WHITE'S
NOSE NOT SEEN
UNLESS IN PROFILE
(SIDE VIEW)

YES!

LIPS ARE
SOFT AND
NOT TOO
FULL

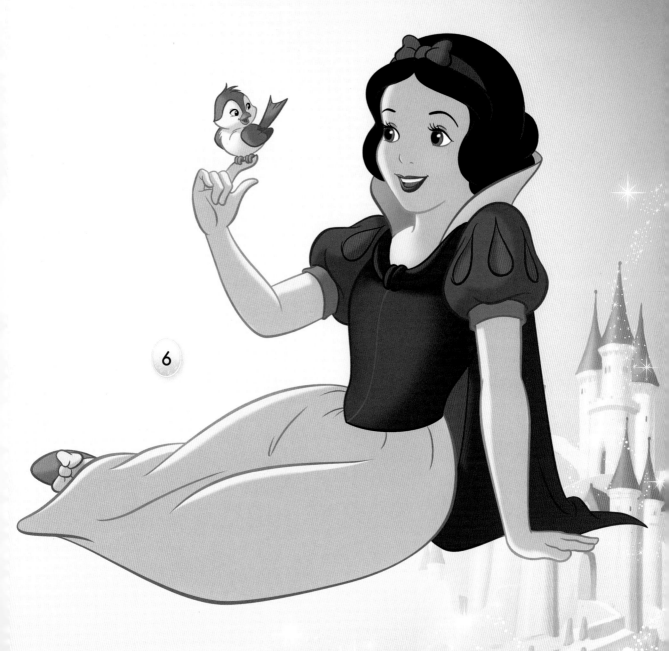

6

The Queen

The Queen, ruled by jealousy, anger, and vanity, tries to thwart Snow White at every turn. She truly is not the fairest one of all.

EYE SHAPE IS "ALMOND"—NOT ROUND;
LASHES CURL UP SOFTLY

YES! NO!

BROW HAS AN S-CURVE; IT'S THICK
ON THE INSIDE EDGE AND TAPERS OUT
TO A THIN LINE

YES!

NO!

NOTE THE SHAPE
OF HER LIPS

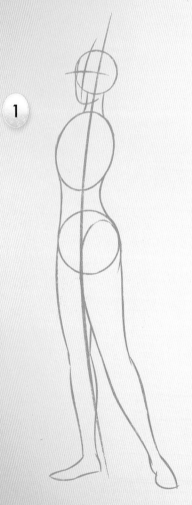

1

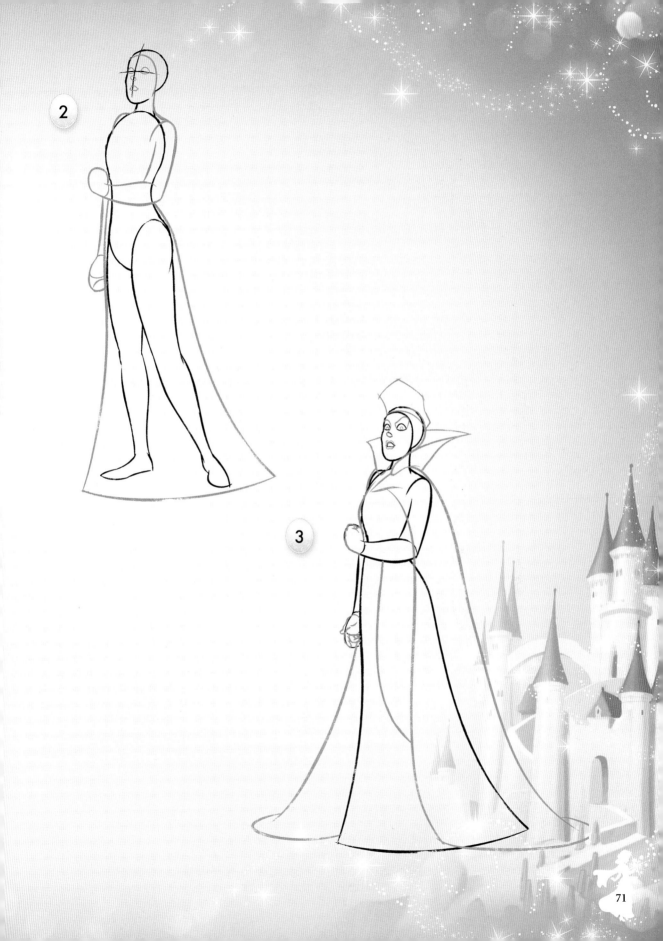

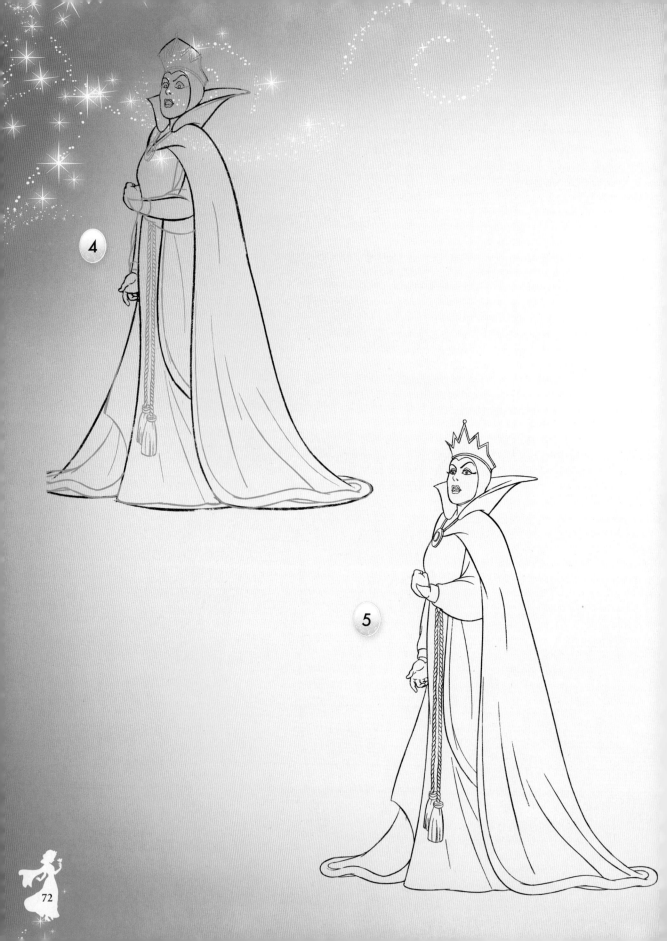

4

5

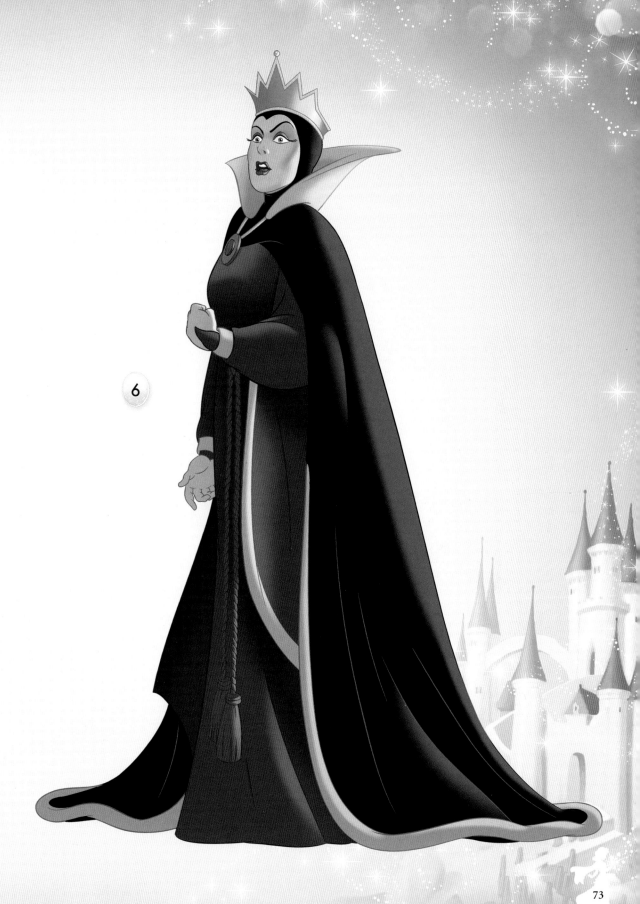

6

The Witch

The evil Queen uses dark magic to transform herself into an old witch in a final attempt to do away with Snow White—by giving her a poison apple.

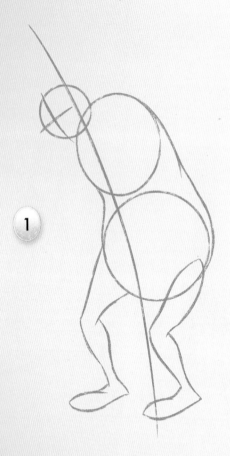

1

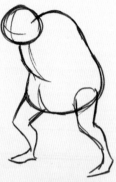

BODY IS SHAPED LIKE A POTATO

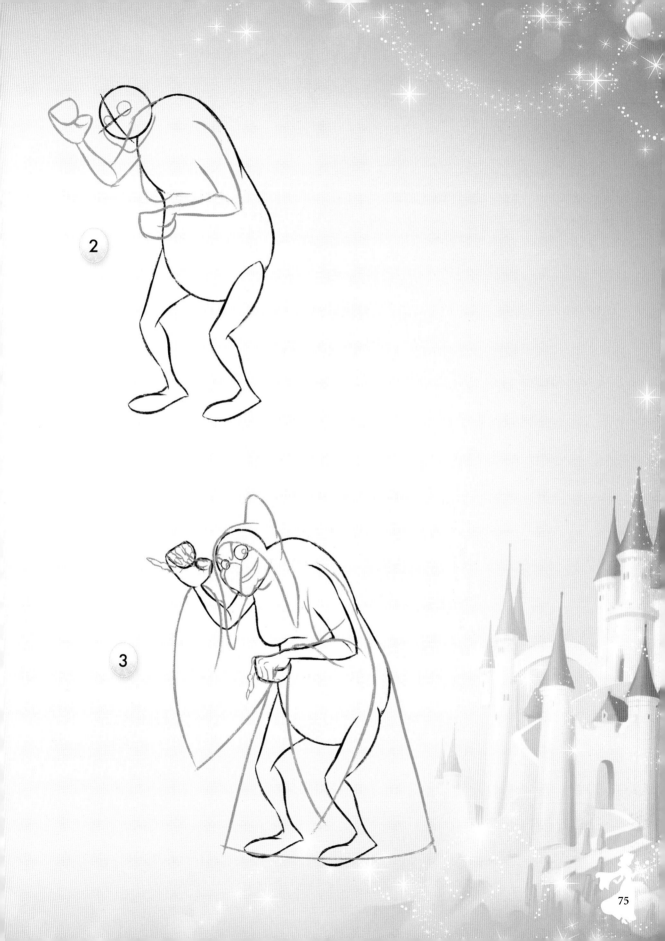

2

3

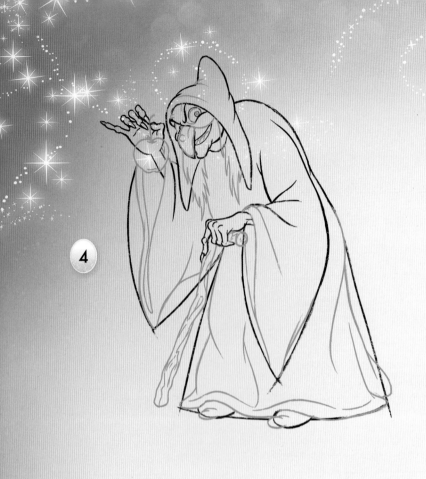

4

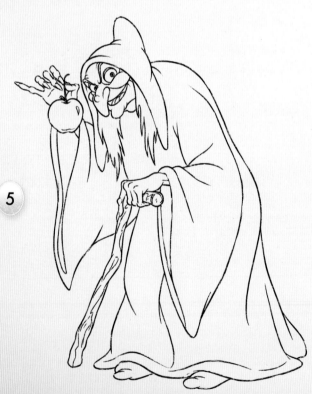

5

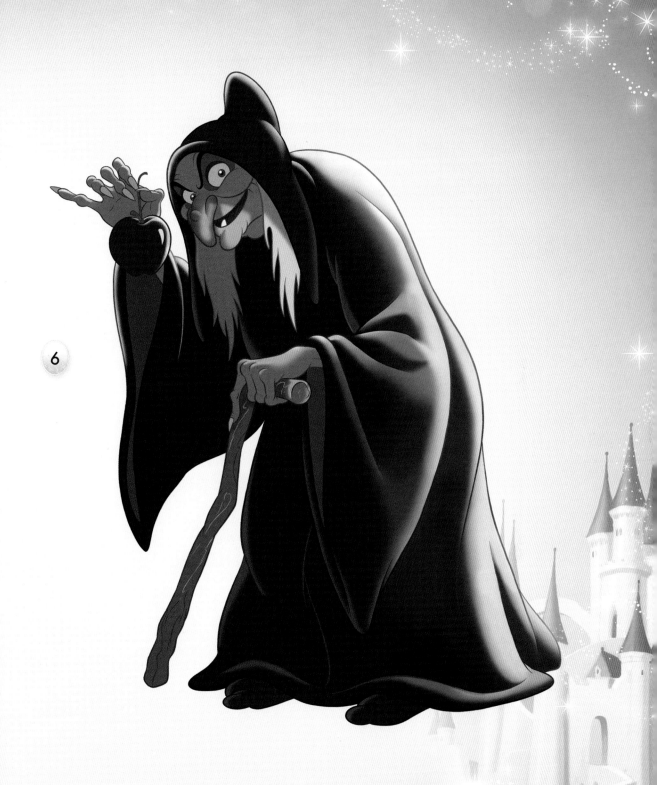

6

Sleeping Beauty

Born into royalty, Princess Aurora is a beautiful, graceful, and sweet young woman. She is innocent and beloved by all who know her, bringing sunshine to everyone's life (contrasting with the darkness of Maleficent). She has "hair of sunshine gold and lips red as the rose."

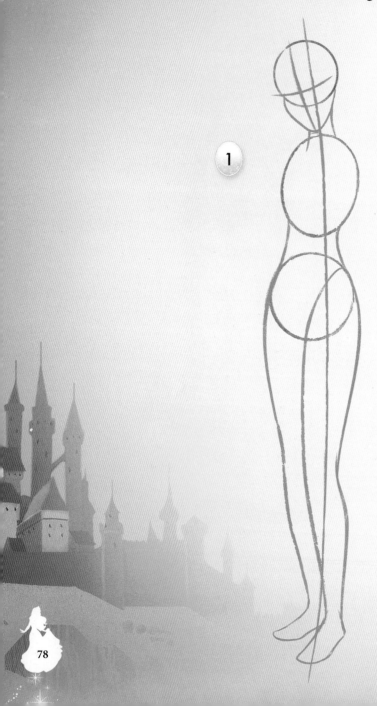

1

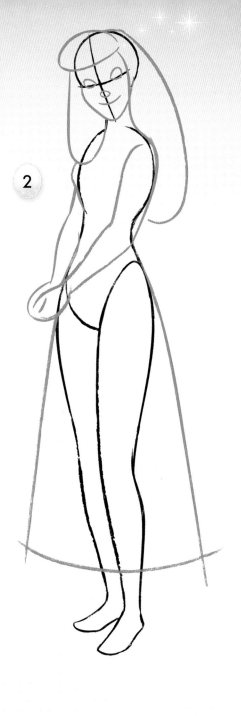

2

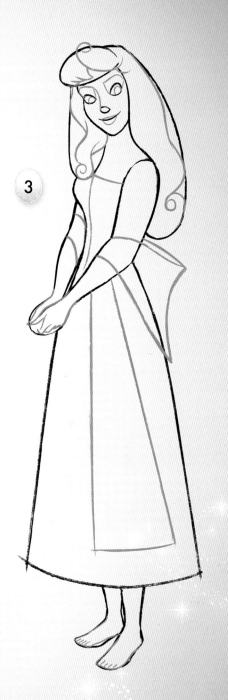

3

THE TOP OF HER HEAD
IS FAIRLY FLAT

SLEEPING BEAUTY'S
FEATURES ARE MORE
ANGULAR THAN
SNOW WHITE'S OR
CINDERELLA'S

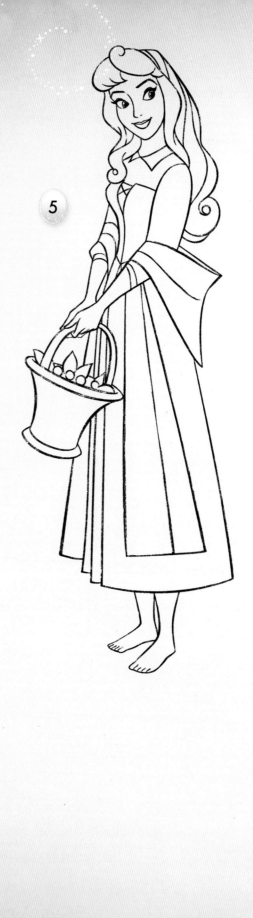

5

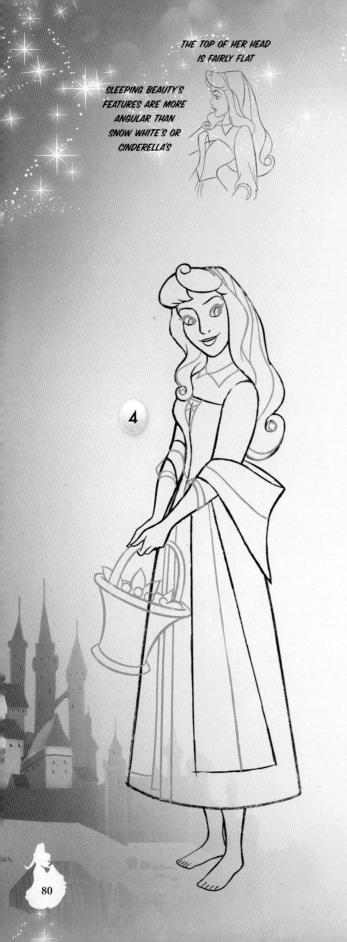

4

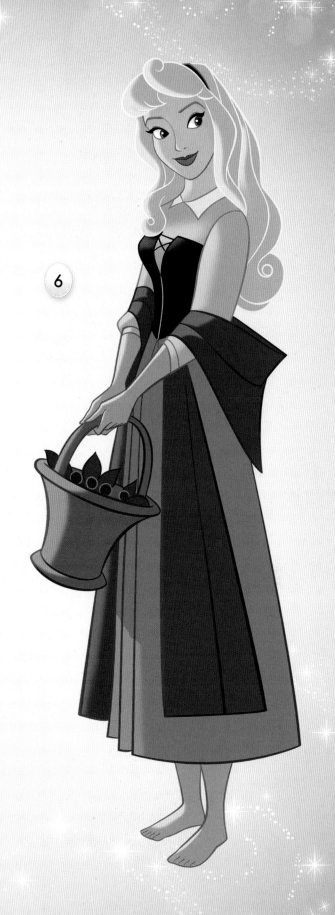

6

*EYES TILT
UP SLIGHTLY*

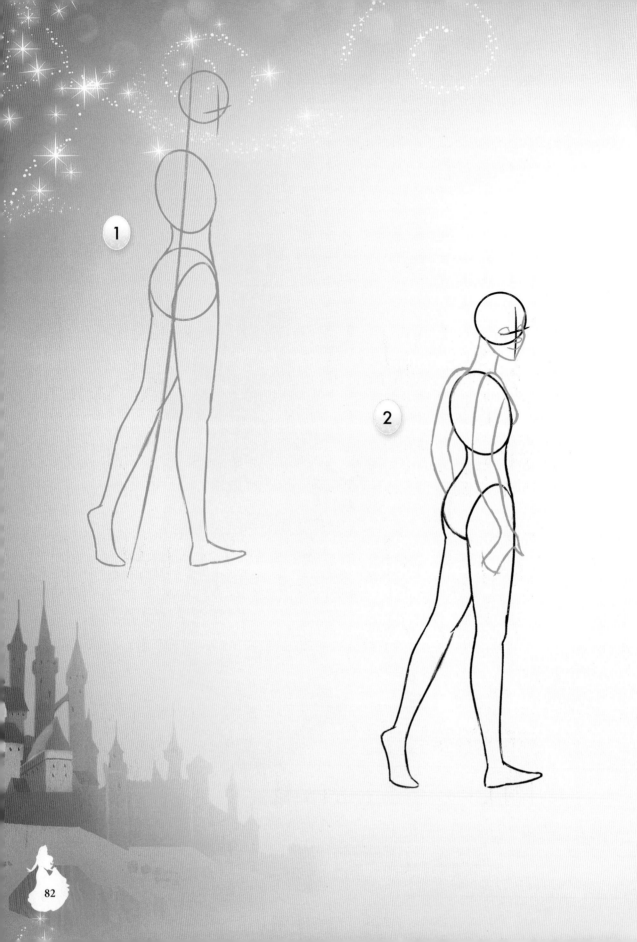

1

2

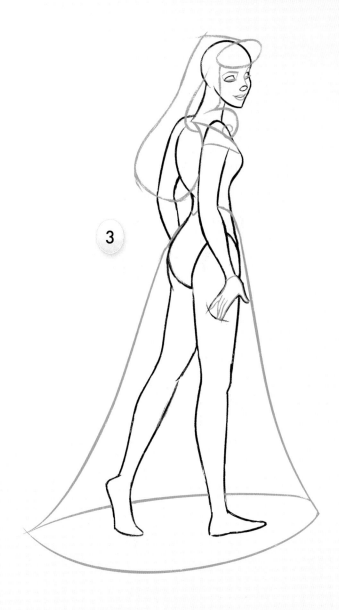

3

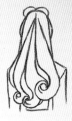

SLEEPING BEAUTY'S
HAIR CURLS LIKE
THIS AT THE BACK

YES! EYES END IN
POINTED CORNERS
AND HAVE ONE
THICK EYELASH

NO! NOT ROUND—
DON'T DRAW
INDIVIDUAL LASHES

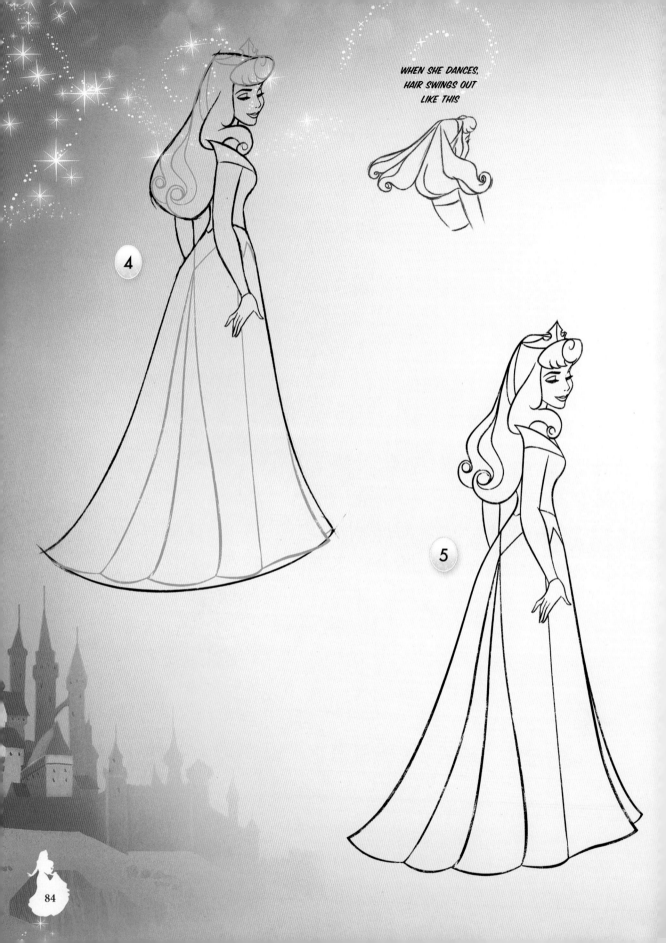

WHEN SHE DANCES,
HAIR SWINGS OUT
LIKE THIS

4

5

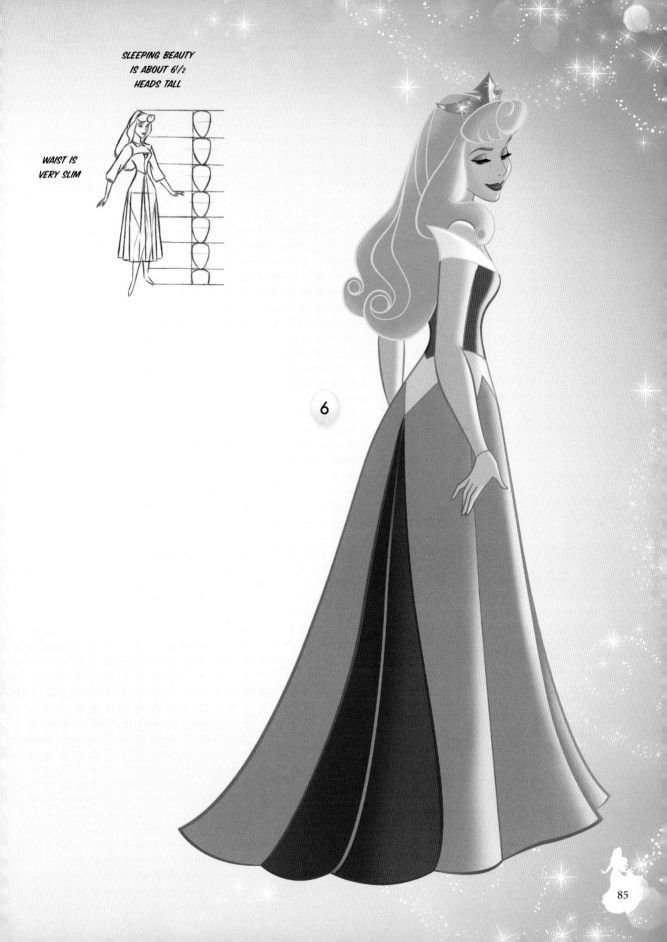

SLEEPING BEAUTY
IS ABOUT 6½
HEADS TALL

WAIST IS
VERY SLIM

6

85

Flora, Fauna & Merryweather

These three good fairies—Flora (in red), Fauna (in green), and Merryweather (in blue)—protect Princess Aurora against the evil Maleficent and help Prince Phillip break the curse and awaken Sleeping Beauty.

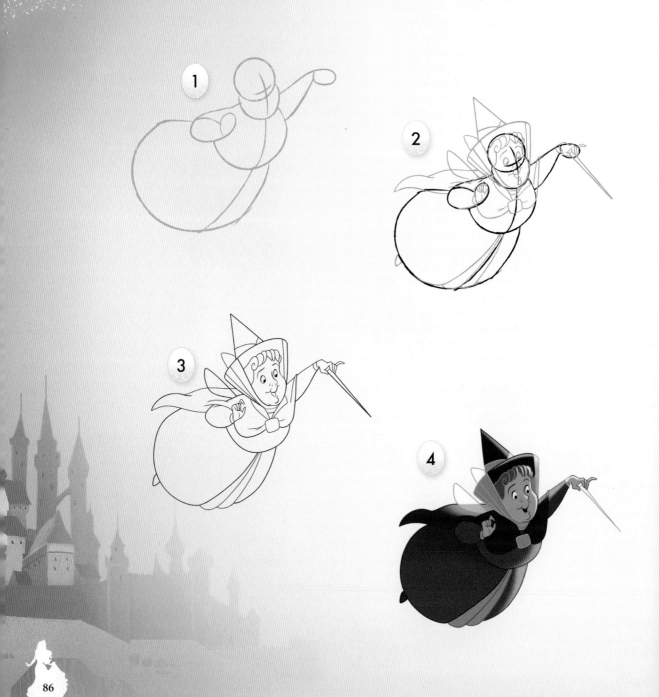

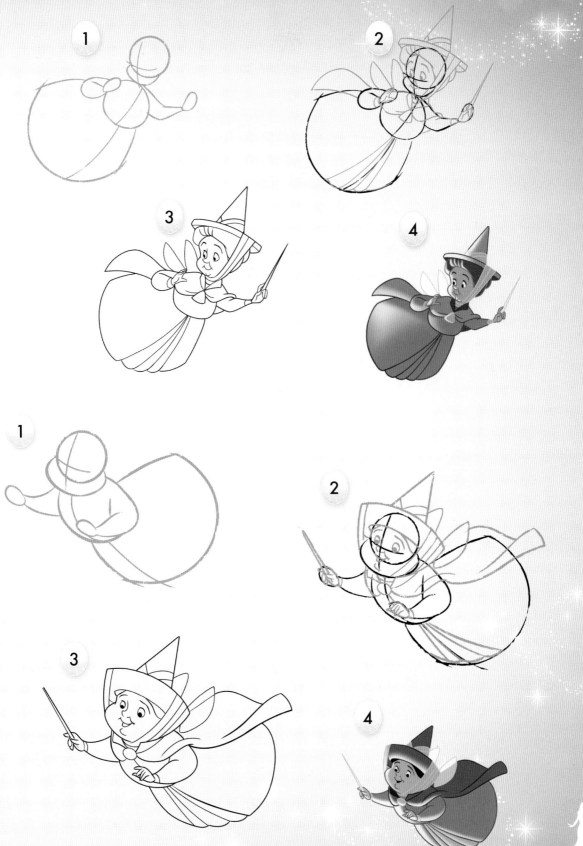

Maleficent

Filled with jealousy, the malevolent witch Maleficent curses Princess Aurora, and no deed is evil enough to stop her from seeing out her plan to the end.

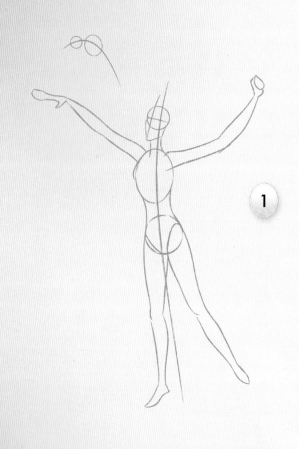

1

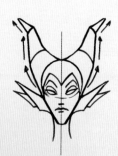

HEAD IS SYMMETRICAL; NOTE THE THREE ANGLES TO THE HORNS ON HER HEADDRESS

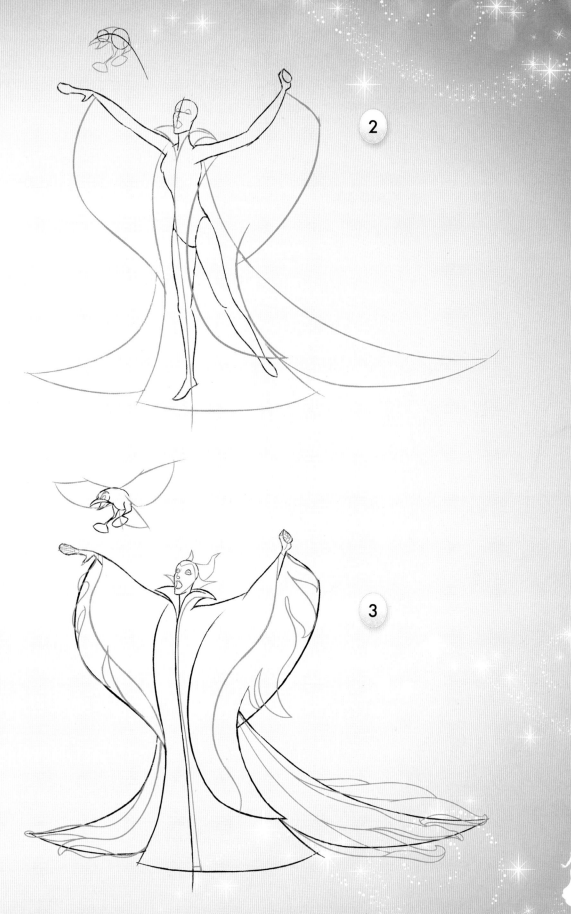

2

3

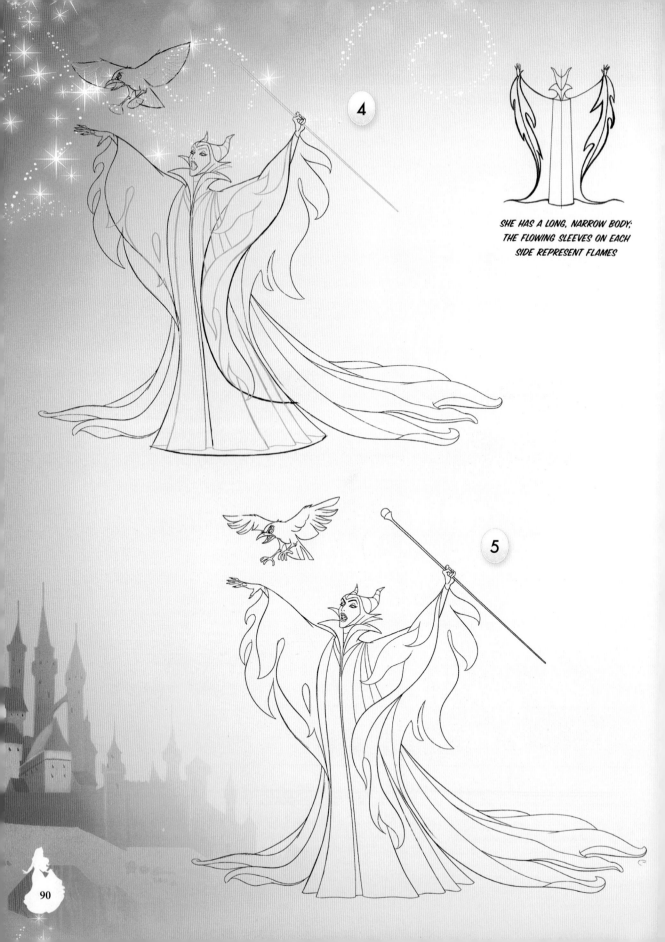

4

SHE HAS A LONG, NARROW BODY;
THE FLOWING SLEEVES ON EACH
SIDE REPRESENT FLAMES

5

*SHE WEARS A LARGE BLACK RING
ON HER RIGHT INDEX FINGER*

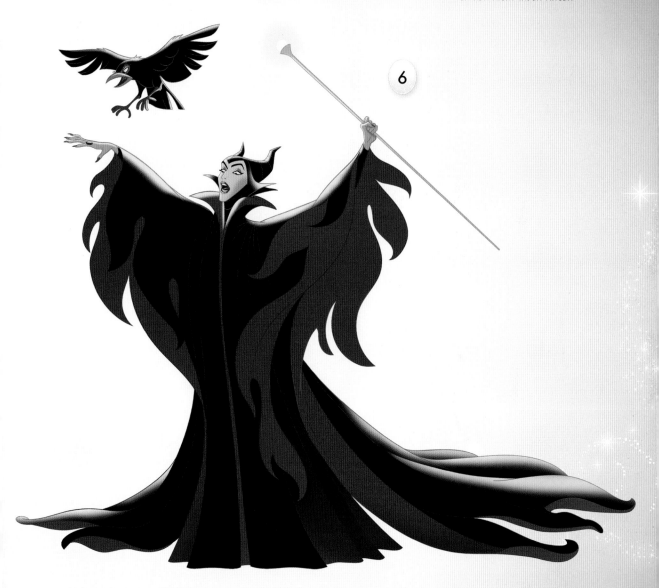

6

Dragon Maleficent

In a last, mighty attempt to stop Prince Phillip from reaching Sleeping Beauty,
Maleficent transforms into a huge, dark dragon in order to drive him away.

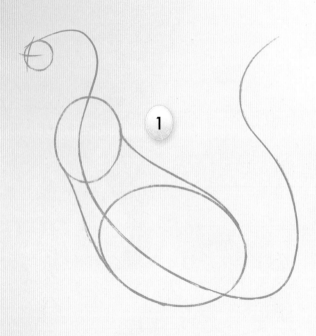

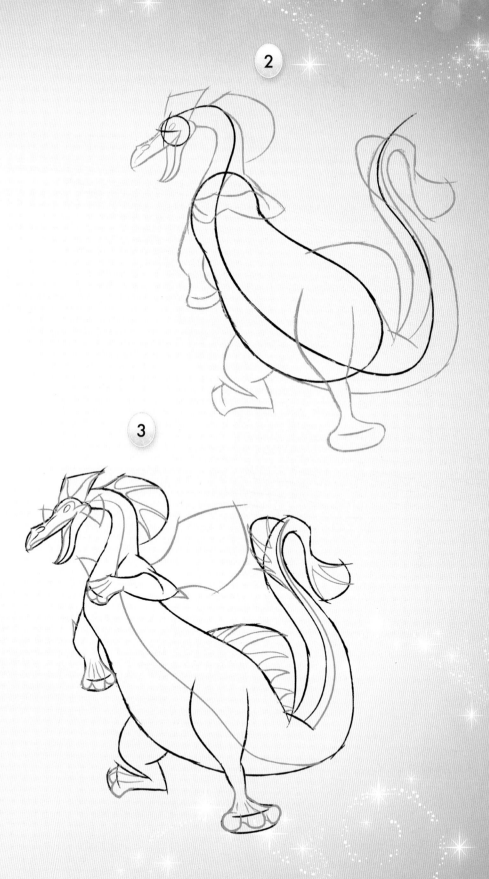

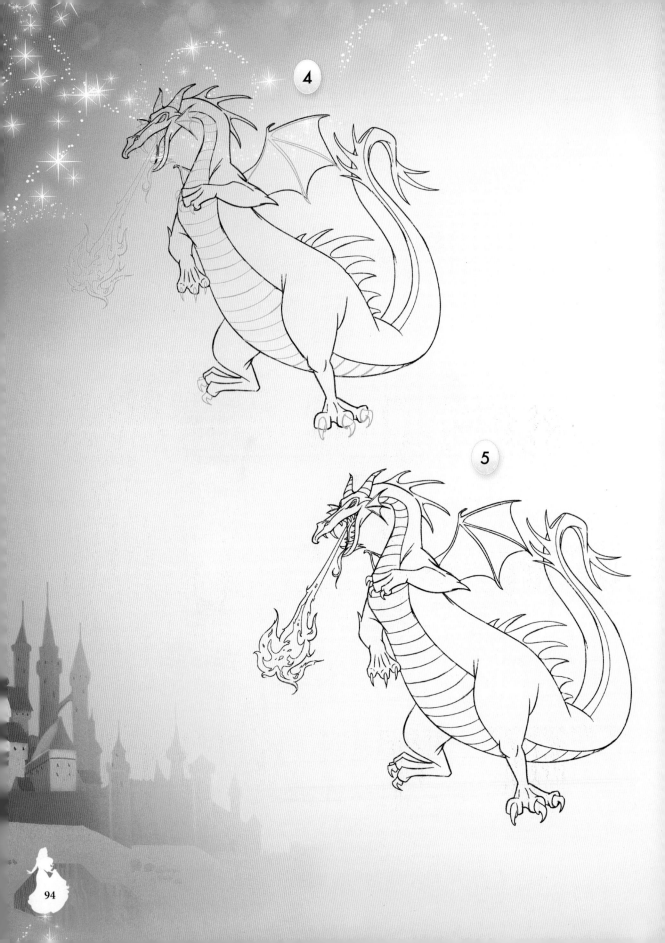

6

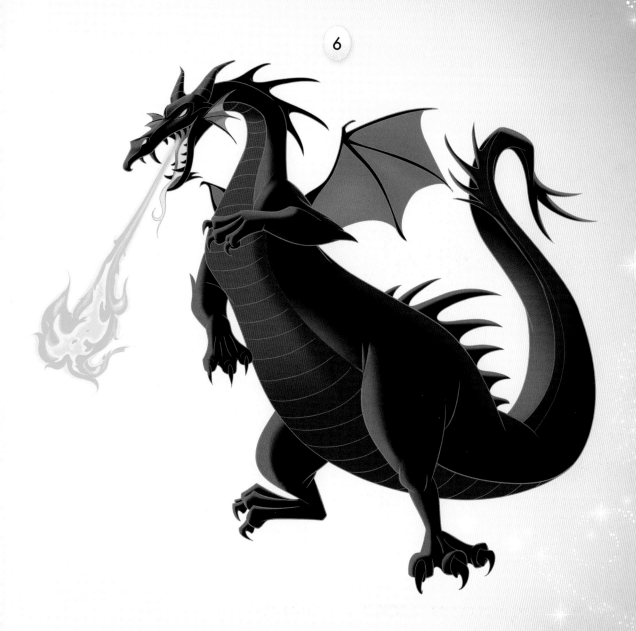

95

The End